CDQ

CHARACTER DESIGN QUARTERLY

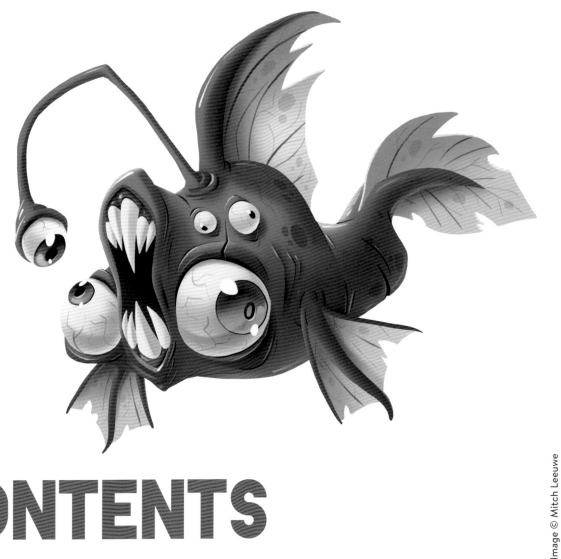

CONTENTS

WELCOME TO *CHARACTER DESIGN QUARTERLY 17*

Hello! It's a pleasure to welcome you to another edition of our jam-packed magazine. This issue is full of weird and wonderful characters, from a murky underwater sea witch, to a cast of misfits ready to hit the Las Vegas Strip, all created by incredibly talented artists and designers.

The scene is set by our striking cover, featuring a majestic female fantasy character created by the hugely talented Dani Diez. I love the way she's almost daring you to open the cover, with her mechanical-looking snake curling behind her.

We're also totally thrilled to catch up with Amanda Jolly, who we last interviewed in the very first issue of *CDQ*. It's amazing to hear what she's been up to over the last few years.

And that's just a hint of what awaits inside... Enjoy!

SAMANTHA RIGBY
EDITOR

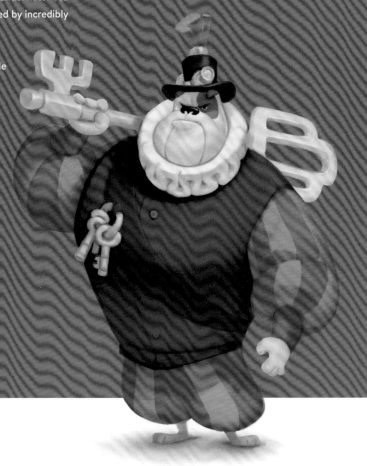

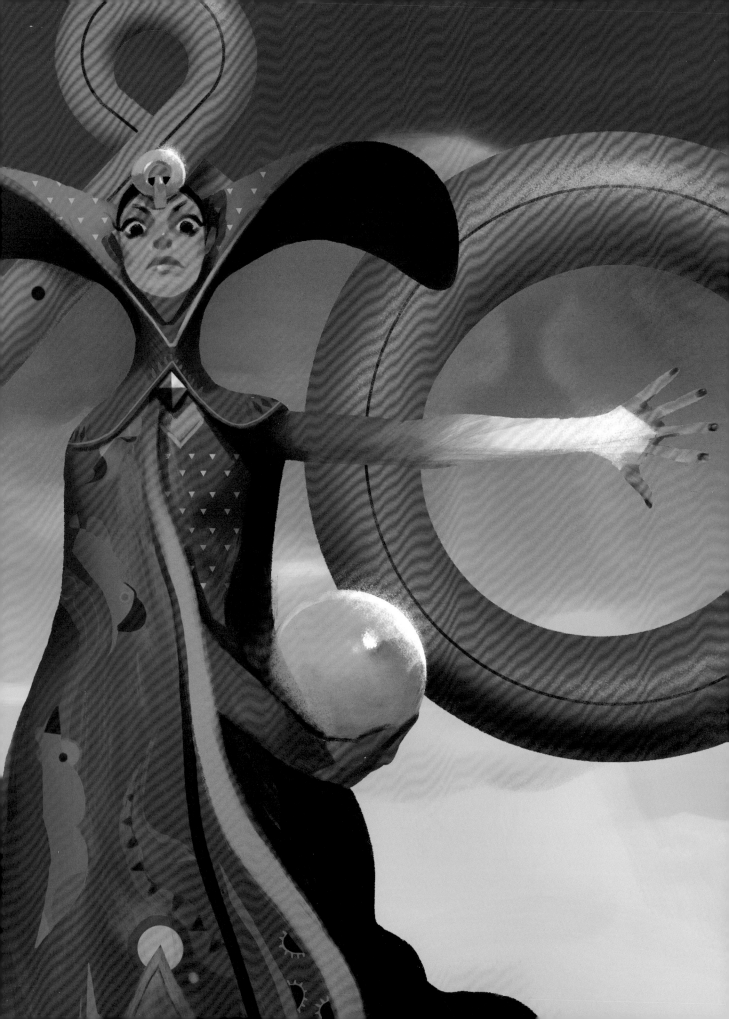

BEHIND THE COVER ART:

Dani DIEZ

This issue's captivating cover has been designed by the extraordinarily talented visual development artist, Dani Diez. In a fascinating interview, he talks to us about his humble beginnings, his biggest inspirations, and his advice to those wanting to break into the industry. Then, from page nine, he takes us through the creation of his stunning cover art.

Hi Dani, thanks for contributing to this issue. Could you tell us a bit about your background in art?

Thanks *CDQ*, it's always a pleasure to work with you. Well, in a way I'm a self-taught artist. I've always loved drawing and, growing up, I always had pencils and paper nearby thanks to my parents. I originally studied architecture, but never finished it, and when I moved to Madrid I did a one-year art course in a private school. I realized there that perseverance and dedication is the most important thing when you're learning a skill – even more important than having a good teacher. I started drawing every day and signing up for online courses from time to time, and that way of doing things definitely worked for me. I'm not advising your readers to go it completely alone – I wish I had the chance to go to a fantastic art school – I'm just saying that without dedication and putting in the hours, there's no art school that can help you improve.

Like most artists, I started my career doing very small jobs while keeping an eye on building my portfolio. I worked on my own art projects in my free time, and then spotted a job opportunity at a Spanish animation company. It can be hard to go to an interview without titles or diplomas to back you up, but luckily for us artists, the drawings speak for themselves. The company liked my work, so I got the job and started developing movies with them.

What do you see as the biggest inspirations for your work?

There are many of them to be honest, but I think my biggest influences have been Akira Toriyama's work and the *Final Fantasy* saga. Watching anime in the 90s gave me the curiosity and inspiration to want to create universes and characters. When I was little, I was completely amazed by Toriyama's universe as it seemed so vivid and positive, and so dangerous and fun at the same time. It was similar with the *Final Fantasy* games – I'm really attracted to those universes where everything just seems to fit in perfectly.

In both Toriyama's work and in *Final Fantasy* games you can find enormous diversity – magic, technology, animal characters, swords, comedy, drama... You could find a vampire count, a military mech, a talking pig, and a space traveler in the same *Dragon Ball* episode. Even today, when I need some inspiration, remembering those universes, and the moods they provoked, makes me want to stop everything and just start drawing.

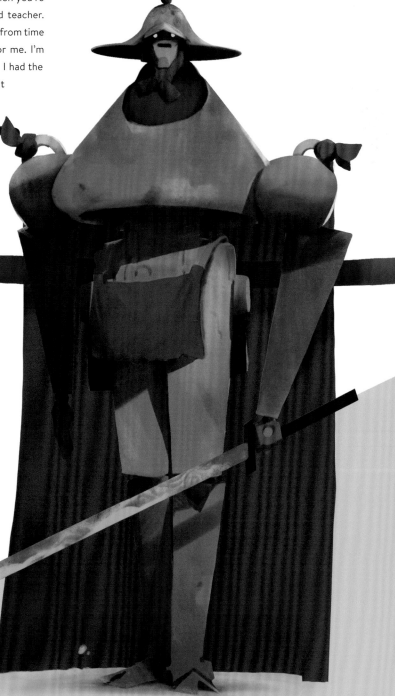

"WITHOUT DEDICATION AND PUTTING IN THE HOURS, THERE'S NO ART SCHOOL THAT CAN HELP YOU IMPROVE"

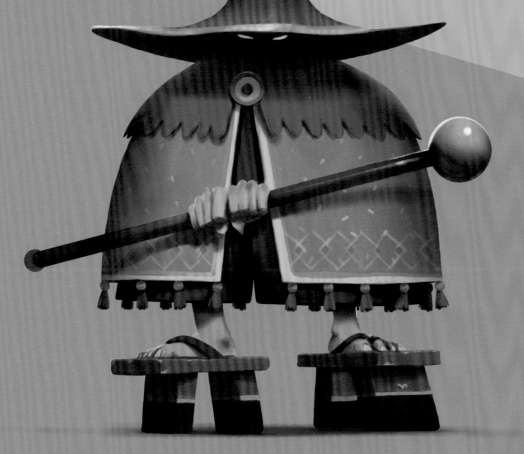

Opposite page: *Tin Samurai* – using simple shapes makes for a bold design

This page: *Nigel the Wizard* – a sense of wonder often comes from hidden parts

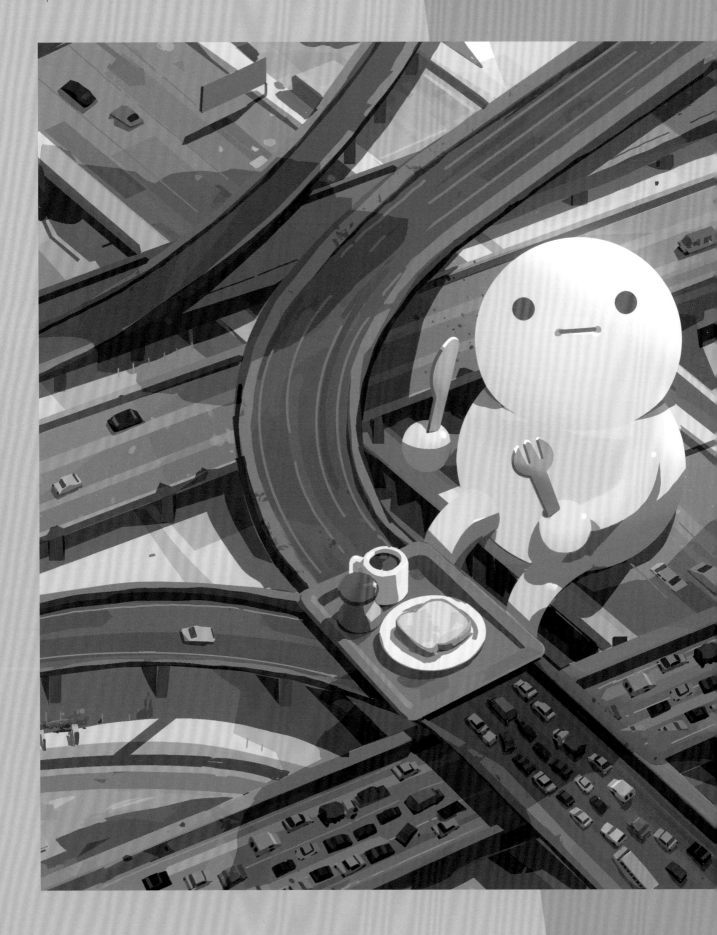

Large image: *Monday Morning* –
a very simple character surrounded
by a complex environment

This page (right): *Kid* – one weird
object can make you wonder
who this character could be

You often play around with proportions and shape in your work – was this something that came naturally?

That style has really developed over the years. I've been through many phases, wanting my art to be one way or another. I tend to experiment a lot and, as a consequence, my style is in a constant state of change. Lately, I've been really attracted to a more graphic style, with bold, simple shapes. Every time you push your style out of your comfort zone you learn so much, and to me that feels really good. I have also started sketching smaller and smaller (tiny sketchbooks are the best!), and that has forced me to simplify shapes and play with proportions rather than focus on intricate designs.

All of your designs appear to have a story behind them – is this something you always consider before starting?

Most of the time, the stories actually take shape on the page. When I draw for myself in my free time, I like to focus on shapes, colors, proportions, composition, and so on. I don't think about any particular story before I start, I just set up a mood or begin with a couple of words to remind myself what it is I want to draw. But of course, during the hours you spend on the drawing, you're constantly thinking about the character, and that usually brings up some back-story ideas to incorporate – for example, "What if this guy is actually an exiled member of the Royal Guard instead of just a knight?"

I think the key to designing characters that appear to have a full back-story is to establish something simple and clear about them, and to incorporate elements that reflect that into the design. It might sound silly but, to me, a good way to create the story is to imagine that a character belongs to a 90s fighting game, let's say *Street Fighter*. In those games, they had really small background stories that made the characters hugely appealing, and those stories were usually presented as a single sentence that summarized the life of the character. So, I try to find a simple sentence that works for my character and show it through the design.

Have you faced any challenges working in the art and design industry?

Well, as a mostly self-taught artist, I didn't have much visibility of how the industry operated until I was in it. I always tried to trust my instincts and use common sense, but most of what I know I learned on the go, which has been challenging at times. Looking back, I've probably always jumped into things before I was ready, but you know, that's part of the fun!

Another common struggle for me is finding a balance between working for others and working on my personal projects. But I think it's important to keep fighting for that balance and maintaining both sides, as both help you to grow so much as an artist.

What do you consider to be the most important elements of character design?

To me, the basis of a good character is in the design itself – where each part of the character can be reduced to a simple geometric shape that contrasts and balances with the others. Being able to make this system of shapes work together is the most important part of designing. Practicing this is a matter of playing with shapes – in the early design stages, I tend to make ten shape studies rather than one elaborate sketch.

Another important thing is the ability to contain yourself when designing. For me, it's all too easy to get excited and want to put everything everywhere! But the emptier areas of a design are just as important as the intricate ones. You can only put emphasis on a design detail if you make room for it to be important – the only way to show off a bright spotlight is by placing it in a darker area.

This page:

Ka and the Magic Pot – synthesizing shapes to focus only on the important parts

Opposite page:

The Brothers – focusing on the mood rather than the details

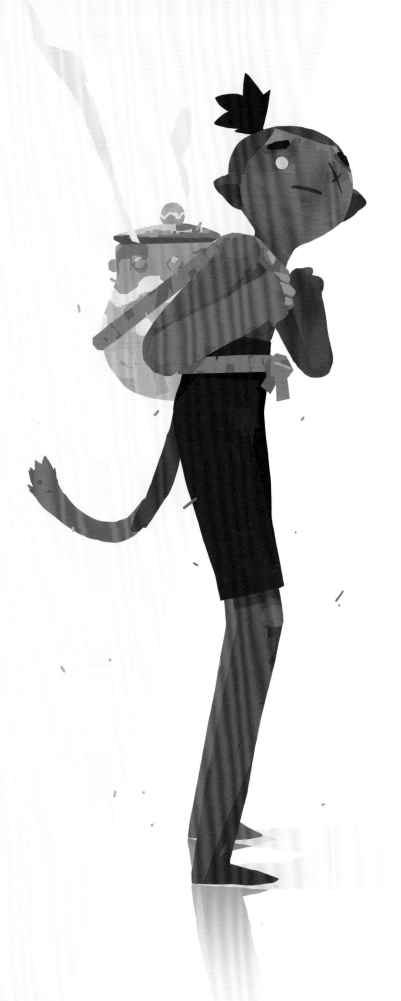

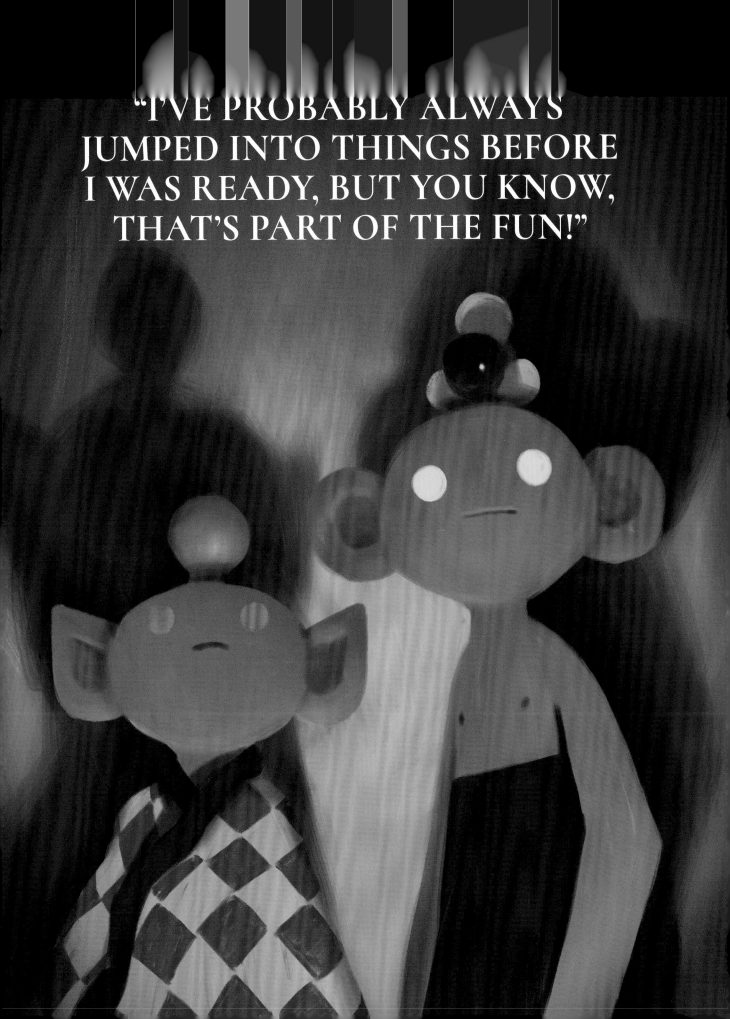

CRAFTING THE COVER

In this step-by-step breakdown, I'll focus on the key stages to consider when creating a character design. Each drawing is different, but once you're familiar with the overall process, it becomes easier to know what to do. You can then enjoy the process of drawing, rather than worrying about unnecessary things. For this cover piece, I begin by sketching in a sketchbook to settle on an idea. For the sketch stages, my preferred medium at the moment is pencil in red and blue. For the final drawing I'll be using Procreate on the iPad.

IDEAS

You might feel like you need one big, fantastic idea in order to get started, but you don't need to wait for that in order to begin. To me, an idea can be quite abstract – more like a mood you want to achieve rather than a specific scene or character. In this case, I know I want a dark character staring directly at the viewer. The starting point can also be something you just want to try out. I would really like to experiment with gradients, for example, so I'm going into my design with this idea in mind. For me, ideas come from observing the world and seeing everything as a potential source of inspiration. You don't have to be thinking about art 100 percent of the time, but if you see something that interests you, write it down or doodle it. It could come in handy later on!

SKETCHES

I want to create a majestic character, who is clearly from a fantasy world, with a strong sense of wonder around them. On the other hand, having recently been interested in bold, graphic design, I want to find an excuse to introduce geometric shapes into the design. With these directions in mind, I start a very small and simple sketch. I try to incorporate

my initial thoughts in some way while sketching very simple shapes. Sometimes, these initial sketches evolve into something else, but just as often the first one is the one that progresses. For this stage I usually use a tiny sketchbook and mechanical pencil.

LINE SKETCH

Once I've done the basic sketch, I like to look at my work and determine with a little more precision what I want to achieve. In this case, I would like the design to be symmetrical, the shapes to be simple and wavy, and to create a cool composition in the background with some geometric shapes. With this in mind, I can further define my drawing and put down some solid line work – I find it's really important to have a goal before you put this down, otherwise it's easy to lose yourself in unnecessary details or things that play against your original idea.

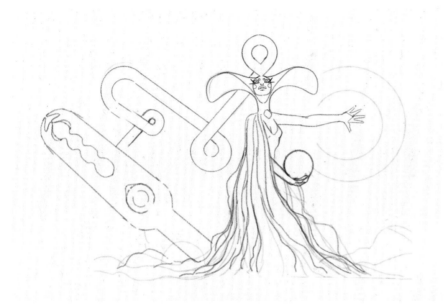

COLOR

It's color time! There are several ways you can approach color. Sometimes I do a color sketch, but sometimes I don't – it depends purely on the complexity of the drawing. With a very complex drawing with many layers, it can become very tedious to try color combinations, so it's best to start working on a smaller area first until you like the palette. However, this drawing has only three basic elements – the character, the snake, and the background (which is going to remain rather simple). I pick out just a few colors to begin with, and once I am happy with the colors I can work on subtle variations within the design.

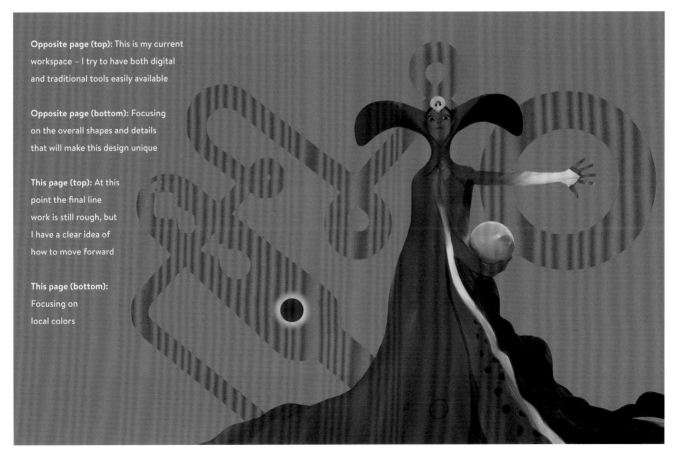

Opposite page (top): This is my current workspace – I try to have both digital and traditional tools easily available

Opposite page (bottom): Focusing on the overall shapes and details that will make this design unique

This page (top): At this point the final line work is still rough, but I have a clear idea of how to move forward

This page (bottom): Focusing on local colors

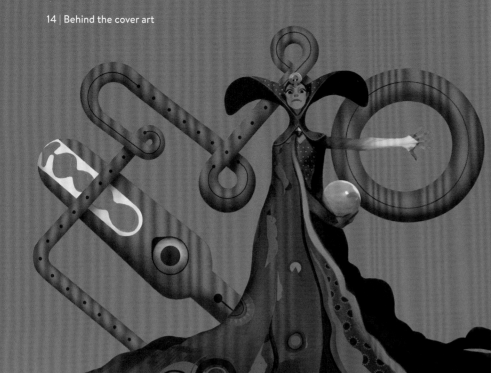

RENDERING

It's really important to keep the color palette you've picked in mind and ensure you stick to it. I want my character to be blue, but I also want to include lots of other colors within her dress pattern. To keep things coherent, all the colors in her dress need to remain close to the main blue. They may be perceived as greens or reds, but are actually pale blues and purples. At this stage, you also need to pay attention to your values. I previously decided that the character should be the darkest element of the illustration, with the snake as medium, and the background as the lightest value. To check I am maintaining this, I can quickly switch the illustration to grayscale – this allows me to easily see the dark and light shades within the illustration and make adjustments if needed.

FINAL IMAGE

A design can either really improve in the last steps or start to lose clarity pretty easily. When you start rendering the final image, remember the focal points – where do you want the attention of the viewer to land? In my case, I want to draw focus to the main character, her left hand, and the snake's face. This means I need to contain myself in other areas in order to draw the focus to them. For instance, I could add a very cool energy effect on the yellow sphere, but instead I leave it as a subtle shiny spot so it doesn't compete with the character's face. The same with the sky and clouds – I decide to leave them almost monochrome so the character pops.

This page: Once the base is established, it's time to work on the rendering

Opposite page: Focusing on the quality of the materials during final rendering

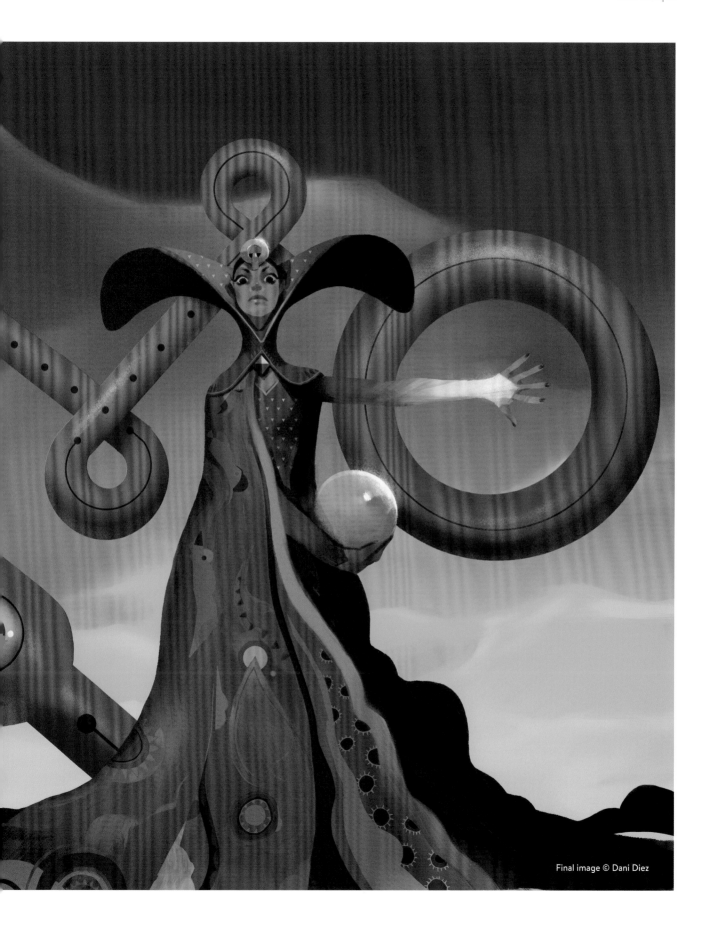

Final image © Dani Diez

Characterize this:
Gate guardian

VERONICA MATEI

Working in game design has taught me to focus on two important factors when designing characters – readability and clarity. In this feature, I will show you how to construct a character from two words, "gate" and "guardian." Throughout the steps I will suggest techniques and processes that can be applied to most digital-painting software to help you create clear and cohesive designs.

Find the key

To begin, break down the key words of your brief to develop your character. This will help inform their shape, personality, and features. You can research associated words to generate ideas for your character, which will allow you to develop an informed and cohesive design.

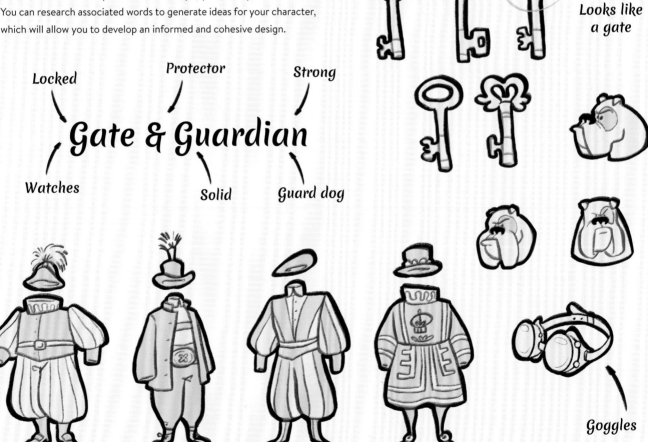

Locked

Protector

Strong

Gate & Guardian

Watches

Solid

Guard dog

Looks like a gate

Goggles

Historical uniforms

Open the gate

Once you have a good idea for your character design, you need to start exploring how they move and interact with their environment. Consider how your character's proportions affect their movement and expressions, as well as how your characters would act in their role. For poses, begin by figuring out the line of action and how the character's volumes will flow through it.

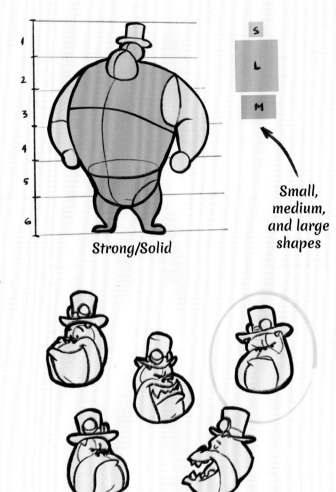

Strong/Solid

Small, medium, and large shapes

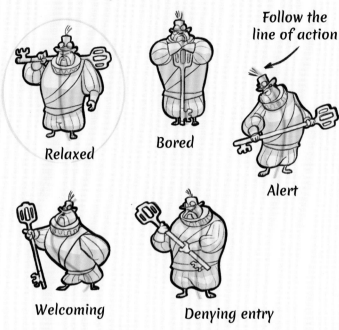

Relaxed

Bored

Follow the line of action

Alert

Welcoming

Denying entry

Guards!

As you move on to the line work, try to keep the construction of the character in mind. Pick a pose that you think best suits your character, and define the lines so they clearly communicate the forms and overall silhouette. As you refine the design, you can add personality through their expression, clothing, and accessories.

Clear silhouette

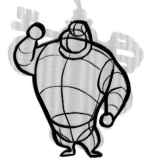

Clear forms

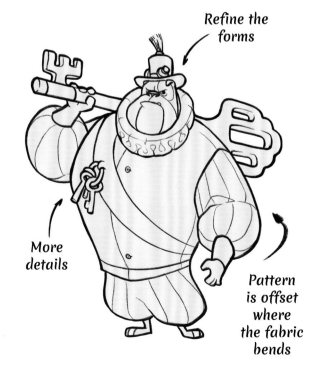

Refine the forms

More details

Pattern is offset where the fabric bends

The light brigade

With a light source in mind, start sculpting the forms using the silhouette and lines as a base, remembering to darken the areas where the light doesn't reach. This technique is called ambient occlusion – figuring out which parts of the object are exposed to light and which are not. Adding a light source and sculpting the forms will make your character appear more 3D and "alive."

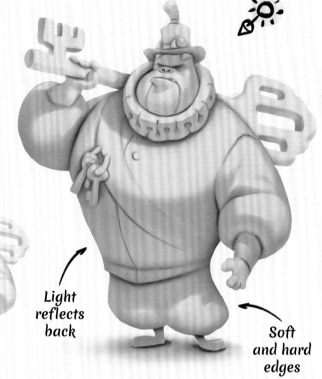

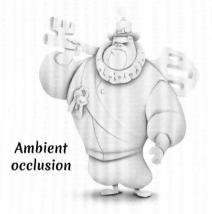

Ambient occlusion

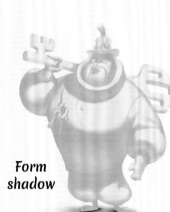

Form shadow

Light reflects back

Soft and hard edges

Trooping the color

When you start to color a piece, it's important to first consider the values (the light and dark areas of the character). We want to create contrast by including light, medium, and dark areas within the image. Creating a black-and-white version to refer to will help you stick to your planned values when selecting colors. I choose a purple for the main body of the character, then I select colors that lie close to it on the color wheel, creating a harmonious color palette.

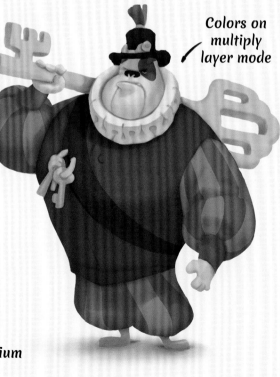

Colors on multiply layer mode

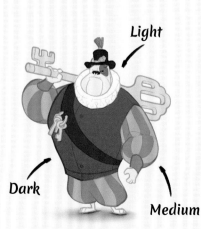

Light

Dark

Medium

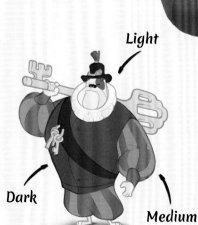

Light

Dark

Medium

Attention!

Once you've settled on a color scheme, it's time to merge everything and look at the design as a whole. Add a little interest by including some color variation and texture when rendering the details to make the design come to life.

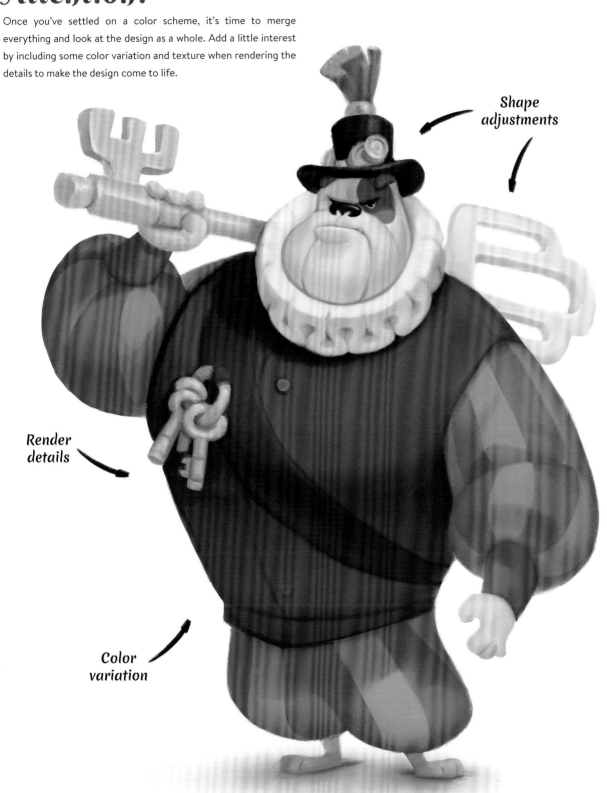

Shape adjustments

Render details

Color variation

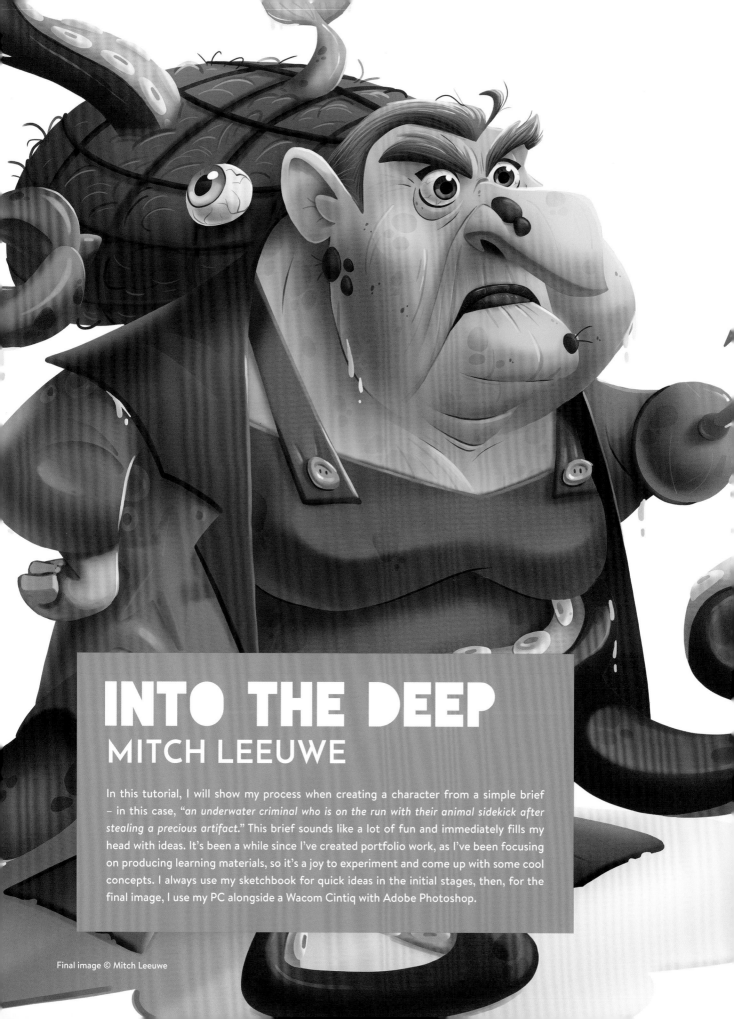

INTO THE DEEP
MITCH LEEUWE

In this tutorial, I will show my process when creating a character from a simple brief – in this case, *"an underwater criminal who is on the run with their animal sidekick after stealing a precious artifact."* This brief sounds like a lot of fun and immediately fills my head with ideas. It's been a while since I've created portfolio work, as I've been focusing on producing learning materials, so it's a joy to experiment and come up with some cool concepts. I always use my sketchbook for quick ideas in the initial stages, then, for the final image, I use my PC alongside a Wacom Cintiq with Adobe Photoshop.

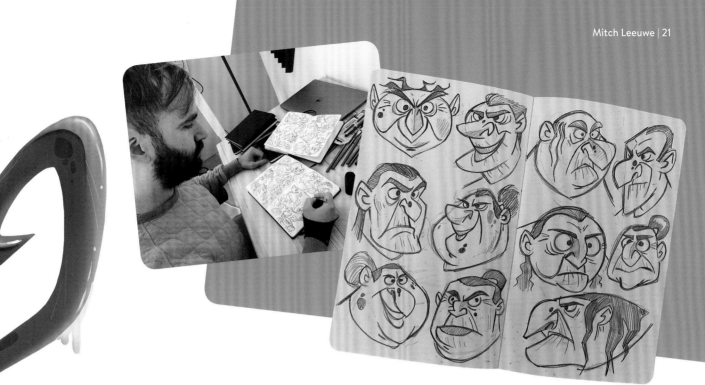

SETTING SAIL

It's important to carefully read the brief before you start drawing. You could write down the brief on a sticky note and put it on your desk or computer screen to remind you of the important points. After taking in the brief, I start to imagine a character – an old sea-faring woman, whose ship sunk to the bottom of the ocean, with her in it, years ago. She was saved by the fishes and sea creatures that she had previously been trying to catch, and because of their kindness she now wants to protect them. She has turned into a sea witch and lives under the sea. Now I have an idea of the character in my mind, I start with some rough sketches.

This page: I always like to begin in my sketchbook to get the ball rolling

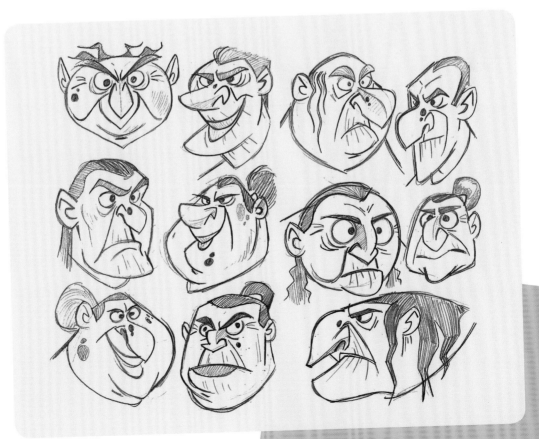

FISHING FOR INSPIRATION

Besides the main character, we also need to think about the animal sidekick. We know our character lives underwater, so I begin by sketching some basic sea creatures. I keep things very generic to start, without going into too much detail, to get the ideas flowing. It's helpful to use Google or Pinterest to find reference images, as this will help you generate ideas and achieve more accurate animal drawings. Once I've drawn this first round of sketches, I step away and let them ruminate in my mind before developing them further. Often, the best ideas come to me in the shower or while I'm out for a walk!

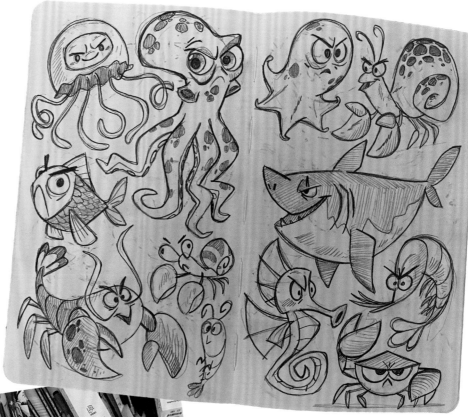

This page: In order to sell the story of the image, the animal sidekick needs just as much care and attention as the main character

Opposite page: Making the first sketches digitally

DEALING WITH ARTIST'S BLOCK

When artist's block happens, I like to use this trick – I take my sketchbook and start drawing random shapes, then draw on top of these shapes again and again. I find this works really well to unlock an idea, like watching clouds tumble over one another. Often you can see all types of characters and objects in clouds and it can really help to get creativity flowing again. I used this technique to find the shape of the witch's head.

DIGITAL DOODLE TIME!

Once I have a rough idea of the concept, thanks to my sketchbook drawings, I start drawing digitally in Photoshop. I create rough doodles, coming up with as many ideas as I possibly can. You could, of course, work directly in Photoshop from the start, but I like to sketch out ideas in a sketchbook first, and then move to working digitally. I do the same when I'm working for a client, but most of the time I don't send the client these rough drawings – they are really just for me to figure out the direction I want to go in.

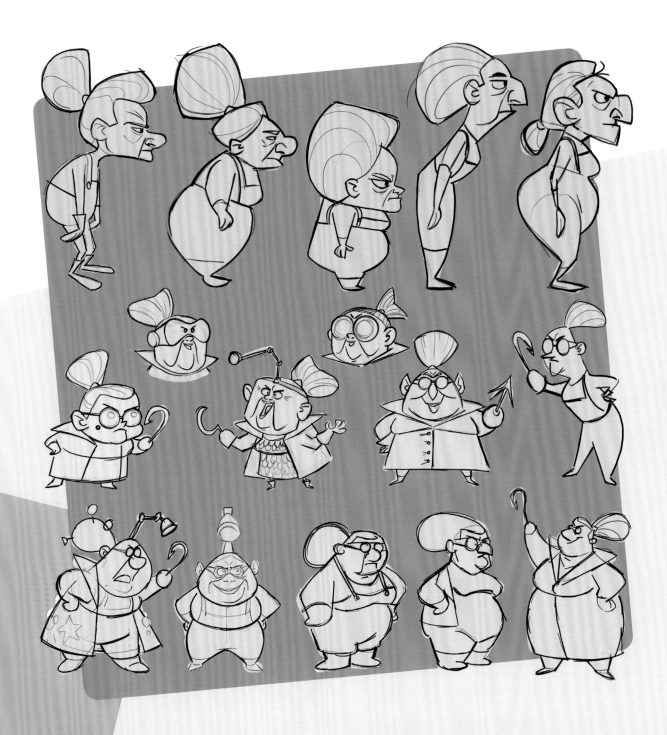

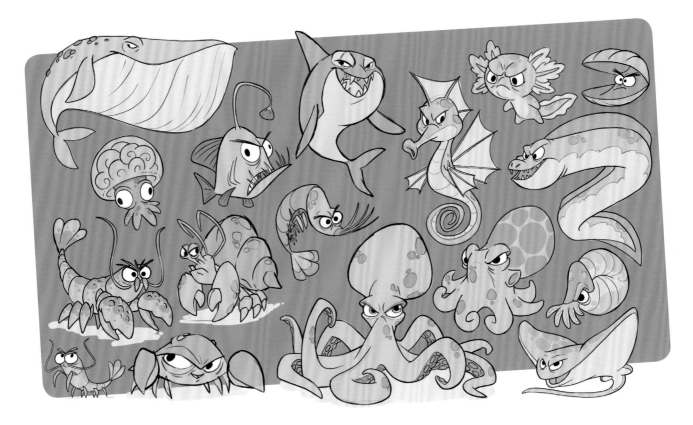

DEVELOPING THE SIDEKICK

I repeat this digital process with the sidekick character sketches. At this point they are still rather generic sea creatures, but the more I draw, the more I start to develop ideas about who they could be and how they relate to the main character. When working to strict deadlines, you may find that this process is condensed and you have to work a lot faster. But for the process of this tutorial, I am showing how you can take advantage of every step, and how creating many different design variations can lead to an interesting final design.

THE SEA WITCH IS BORN

With the previous versions of the sea witch, I tried to just keep it rough and have fun, but now we have to start narrowing down our choices and finding some direction. I take a selection of my existing sketches and add details to increase the appeal, focusing on making the sea witch appear more like an underwater criminal. These sketches should be more defined than the last. As you can see, I've paid attention to details such as clothing to further illustrate her personality. When working for a client, you could share the images from this stage with them as your first proposals.

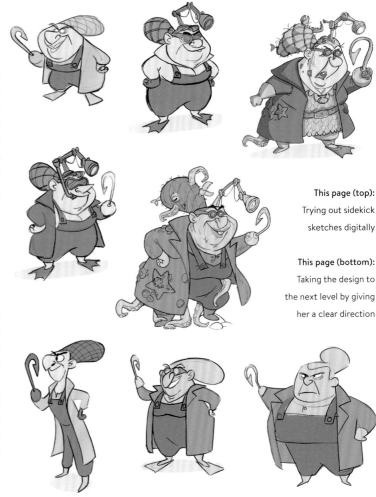

This page (top):
Trying out sidekick sketches digitally

This page (bottom):
Taking the design to the next level by giving her a clear direction

LOOKING FOR CONTRAST

When you are coming up with different versions of your character, pay attention to their shape and how they take up the page. Try creating versions of varying sizes and create contrast between body parts. Even changing the eye position on your character can change up their look. I also like to experiment with different accessories. I ask myself questions such as "should I add goggles to my sea witch or not?" – I won't know until I see versions of her with and without them.

WHAT LURKS BENEATH

Before we move further with the design as a whole, I want to take another look at the sidekick design. When reflecting on the back-story I developed, I realize her sidekick could be one of the first animals she encounters at the bottom of the ocean. Animals from the deep sea are often weird looking creatures, so I take the time to do some research and find photo references so I have an accurate idea of what these animals look like. I take myself to my sofa with my sketchbook to generate even more ideas, combining them with the previous sketches I made, with a deep-sea documentary on in the background for some additional inspiration!

This page: Returning to the sketchbook to generate more sidekick ideas

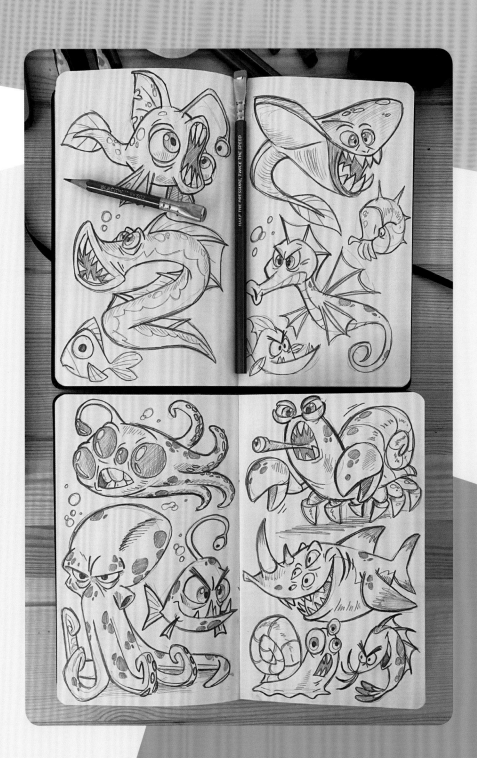

TAKING EVERYTHING ON BOARD

As you can imagine, at this point I have produced many sketches. I take a step back and look at how I can push them further. I decide I need to start combining some of my favorite design elements from multiple sketches in order to create a solid design. For example, I really like the octopus limbs of one design, so I add them to the design with the smaller body. The smaller body with larger limbs makes her appear overrun with sea creatures after spending all those years underwater.

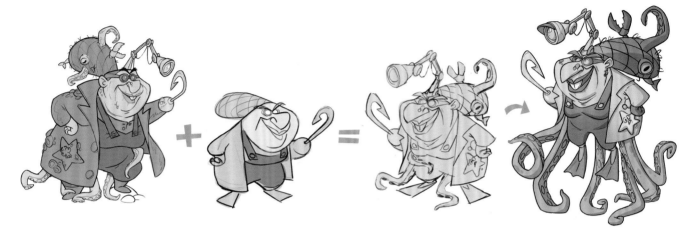

CREATING A CRIMINAL

Now that I've established the general body shape and silhouette for my character, I can focus in on the face. I like to draw many versions, changing up the expressions, nose, and eye shapes to evoke different feelings from my character. As she is a criminal, I want her to look a little stern and intimidating, while also showcasing her age. I experiment with wrinkles, age spots, and eyebrows to help sell her character more.

Remember to continue to push yourself to create quality designs. When working with a client, I would suggest sending them a few versions to showcase the different expressions, but only send three or four rather than a whole folder full, as this shows that you are confident in your own work and decisions.

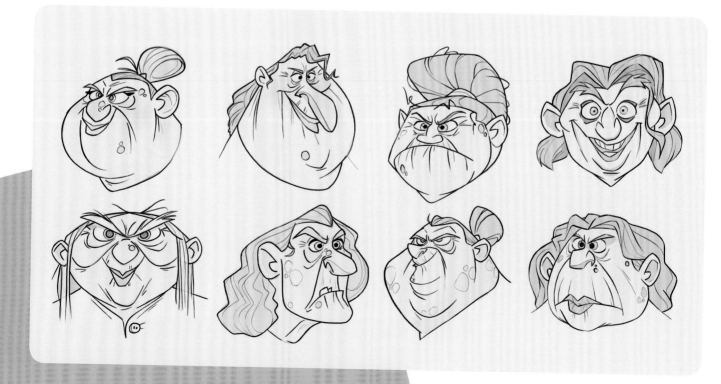

SINK OR SWIM

Now I wanted to push those head designs a notch further, seeing if I can improve on them even more. Adding color and a bit of shading helps me to see how they might look in the final illustration. Even if you already have a favorite design, it's a good idea try out some different things, because you never know when you might discover something better. Narrowing down choices can be much easier when you're working with a client who picks out a final design for you – it can be difficult to make a choice yourself when you've been working on lots of ideas. In place of a client, try asking a friend or relative to give you their favorite options.

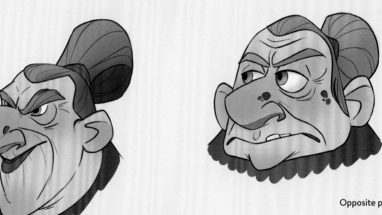

"ADDING COLOR AND A BIT OF SHADING HELPS ME TO SEE HOW THEY MIGHT LOOK IN THE FINAL ILLUSTRATION"

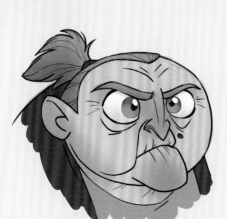

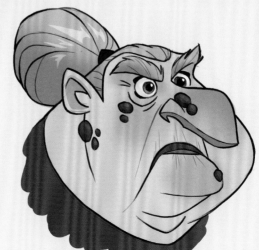

Opposite page (top): You can cherry-pick your favorite elements from different designs and combine them

Opposite page (bottom): Exploring some head designs for our witch so she fits the part of an underwater criminal

This page: Pushing the designs by adding color and shading

REFINING THE SIDEKICK

Now we can bring our sidekick sketches up to the same level as our witch design. I really want to amp up the monstrous elements and make the design more extreme. To do this, I take the sketches of the deep-sea creatures and try to make them appear more aggressive. Paying attention to details like teeth, spikes, and extra eyes will help create some terrifying designs. I want to take the time to add the appropriate features to each monster, so there is a good contrast between them – this will make it easier to select one to bring forward to the final design.

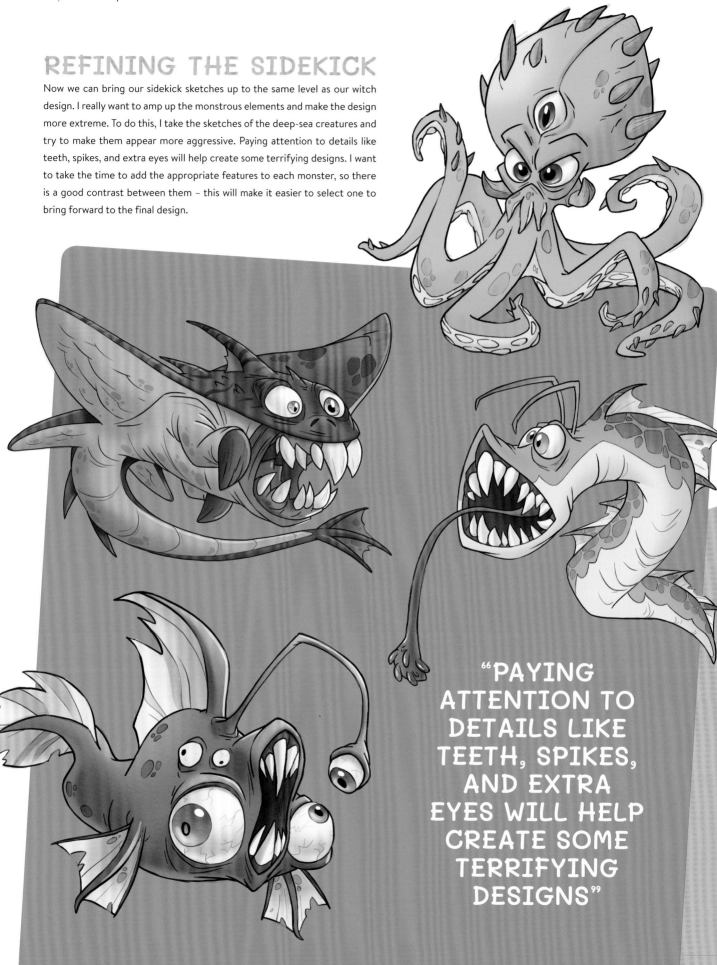

"PAYING ATTENTION TO DETAILS LIKE TEETH, SPIKES, AND EXTRA EYES WILL HELP CREATE SOME TERRIFYING DESIGNS"

ADDING SOMETHING EXTRA

While iterating on the sea witch and sidekick I start to think about other fun ideas I could include, like a deep-sea robot! Because the sea witch sank to the bottom of the sea with her boat, I like the idea that she uses the parts from her shipwreck to build an underwater robot to help commit her crimes. This may just be an excuse, and I may just really want to add a robot, but there's no harm in trying it out! I think it's really important to always try and think outside the box and push yourself in different directions. Don't be scared to stray from the original idea, and always be prepared to scrap earlier work if these new things excite you more.

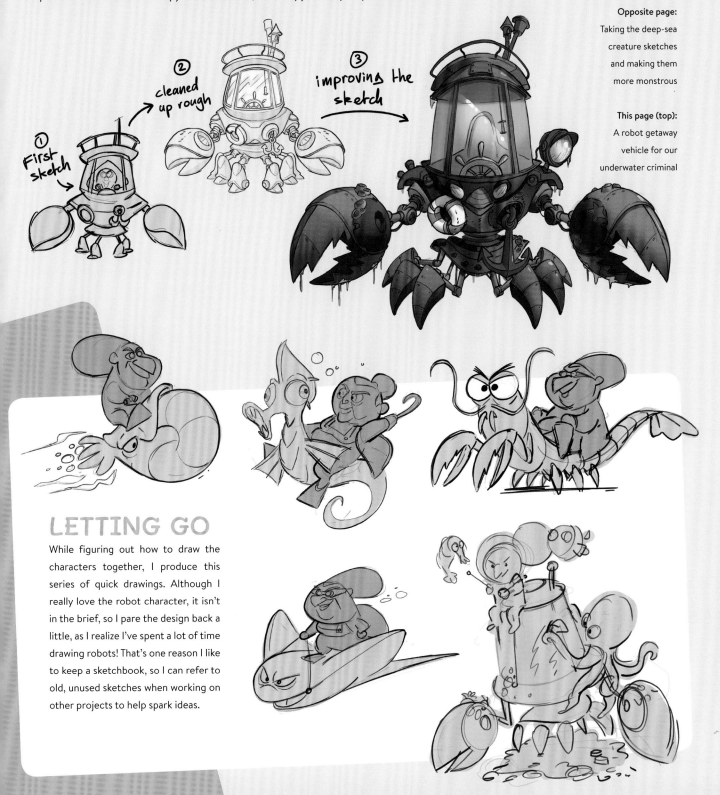

Opposite page:
Taking the deep-sea creature sketches and making them more monstrous

This page (top):
A robot getaway vehicle for our underwater criminal

① First sketch

② cleaned up rough

③ improving the sketch

LETTING GO

While figuring out how to draw the characters together, I produce this series of quick drawings. Although I really love the robot character, it isn't in the brief, so I pare the design back a little, as I realize I've spent a lot of time drawing robots! That's one reason I like to keep a sketchbook, so I can refer to old, unused sketches when working on other projects to help spark ideas.

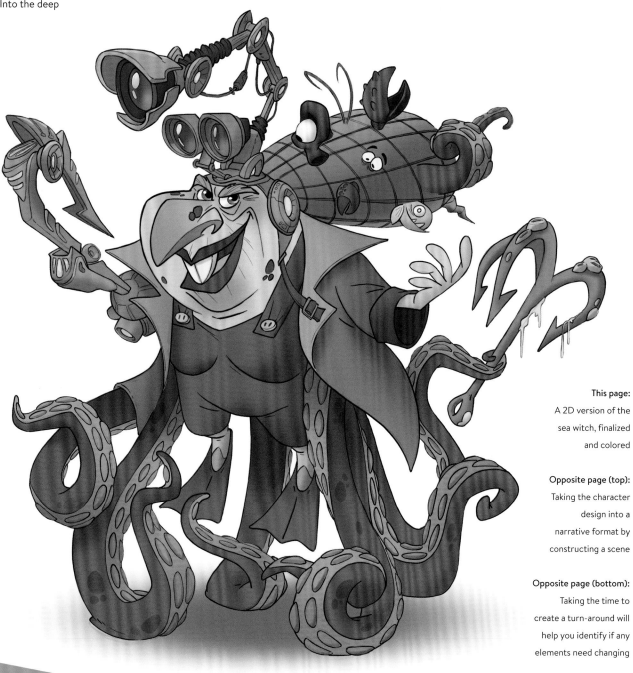

This page:
A 2D version of the
sea witch, finalized
and colored

Opposite page (top):
Taking the character
design into a
narrative format by
constructing a scene

Opposite page (bottom):
Taking the time to
create a turn-around will
help you identify if any
elements need changing

GOING OVERBOARD

I settle upon the idea of the small sea witch with octopus tentacles that carry her along. With my final design in place, I start to finalise the sketch, inking and coloring it. I choose purple as the dominant color, as it is often used for villains. I start adding bits of tech to the witch's design, taken from my ideas for the robot. I think I might have gone a bit overboard and started to add too much stuff, but there's no need to panic. Going too far isn't a bad thing, as it's easy enough to remove things at a later stage. Why not try out different ideas?

ALL HANDS ON DECK

Once the designs are refined to this point, I want to see how they fit together in a character scene. I start to play around with ideas of how they can all interact with one another, so I construct a figure in Blender. This is an amazing piece of software that allows you to construct 3D models – incredibly useful when designing. In Blender, I'm able to adjust the model until I'm happy with the angle, and then screenshot it. I can now take this image and draw on top of it in Photoshop to create the composition I like. You can create the same effect by drawing your characters in different poses, or having them on different layers and moving them around in Photoshop. I decide to show this design to some of my art buddies for review – I find this really useful as a freelancer, as I don't have people sitting around me to bounce ideas off.

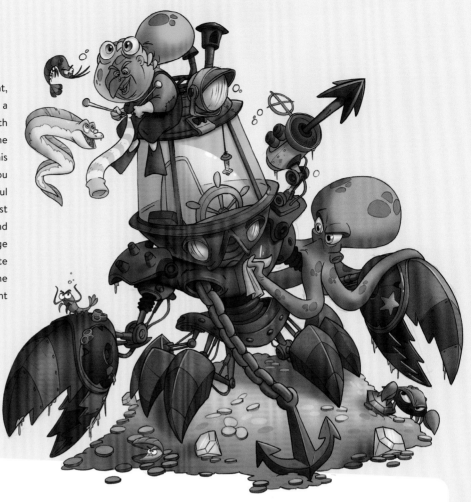

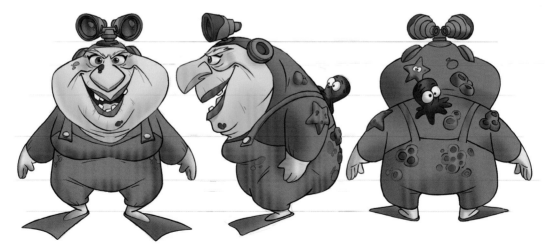

SHOWING HER TRUE COLORS

After receiving feedback from my art friends, I decide to change the skin color of my sea witch. I want it to be clear that she has spent a lot of time underwater, so I eventually land on green, as it makes her appear almost zombie-like.

At this stage, I also like to create a turn-around of my character to see what she looks like from all angles. This is an especially useful tool to provide for clients if your character is going to be animated, as it gives them a clear view of all angles.

This page: The final 3D painted versions of the character design. Final image © Mitch Leeuwe

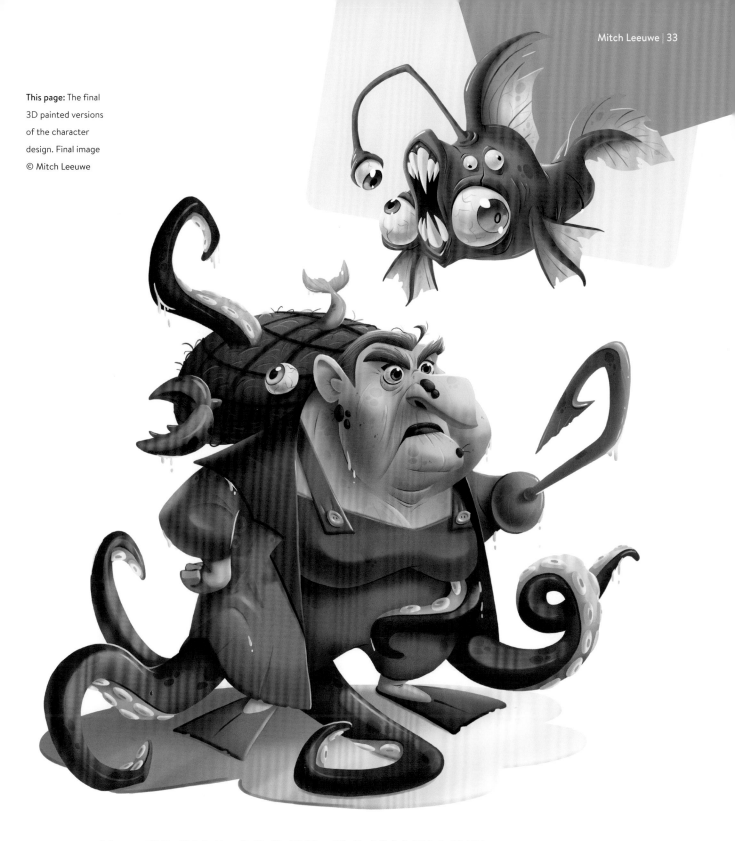

LET THE CRIME SPREE COMMENCE!

The end is nigh! To finish up, I want to take the time to paint my character in a 3D style, to get an idea how it would work in a 3D feature, so I refine the design and add all the finishing touches in this style. Of all the designs I created along the way, I feel this final design fully embodies the character I originally imagined when reading the brief. Despite creating

the robot, I don't include it in the final design, as it wasn't included in the brief. Instead, I focus in on the sidekick, making it more monstrous to match our newly "zombie-esque" main character. Along with her trusty sidekick, our sea criminal is ready to raid the many shipwrecks that litter the ocean floor!

STUDIO SPOTLIGHT:
MUTI

This multidisciplinary, creative South African studio, based in Cape Town, has its talented fingers in many pies. Known for their bold, colorful designs, the Studio Muti artists have worked with top-level companies around the globe, including Google and Nike. We caught up with them to ask how the studio started and how it operates today, and for their advice to budding character designers wanting to get into the industry.

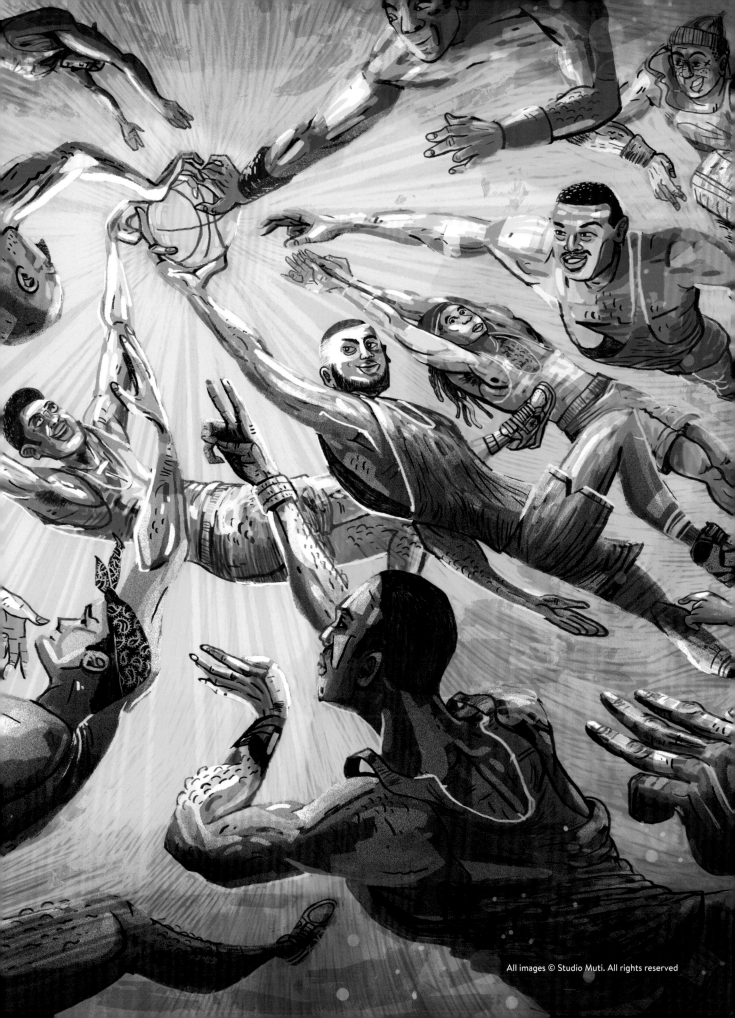

Thanks so much for chatting to us today. Can you tell us a bit about the studio and how it started?

Thanks for having us! Muti started in 2011 when we (Clinton Campbell and Miné Day) joined forces after previously working together on an illustration team. Our first projects were self-initiated – we tried to create a style that would capture the attention and delight of the visual community. From there, clients started to approach us, and with that both the style and team became more varied. In 2013, Brad Hodgskiss joined as the third creative director, after gaining success designing his own T-shirts. Since then, we have continued to develop both self-initiated and client-based projects with our ever-growing team of talented staff. We're now a dedicated team of illustrators, designers, and animators who are passionate about producing original and inspiring work, from lettering to icons, digital painting to animation.

Is there a preference to the types of projects you work on as a studio?

We've worked on a vast array of projects, including garments, publishing, advertising, apps, and branding – so there's no specific industry or client we focus on. For us it's about doing great work, no matter what the application or who the client is. As long as a brief pushes the right buttons for us, we're happy! We love the variety of projects that come into the studio and the challenges some of those projects present. We always have the opportunity to level up our skills with every new project that comes in.

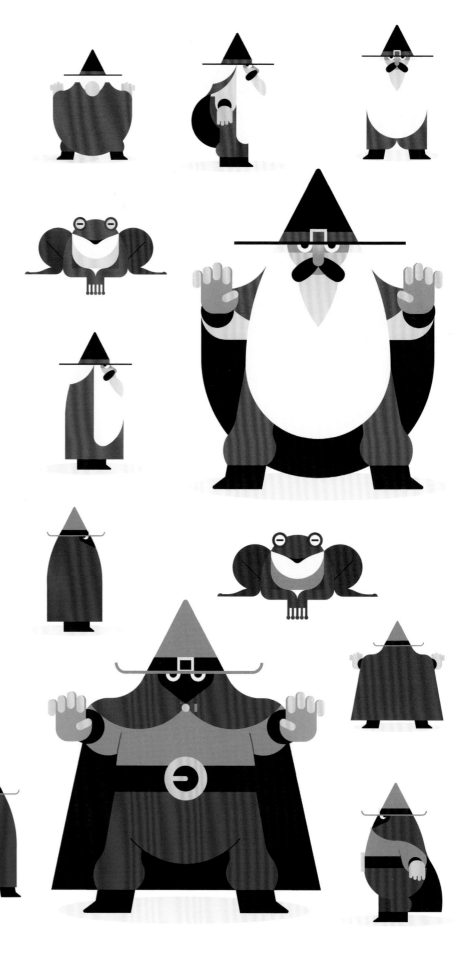

"We've worked on a vast array of projects, including garments, publishing, advertising, apps, and branding"

Opposite page: Character designs for our first animated short – *Los Magos*

This page (top): Originally created as a short looping GIF, this sassy sausage knows who's boss!

This page (bottom): 3D style test

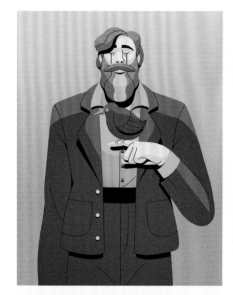

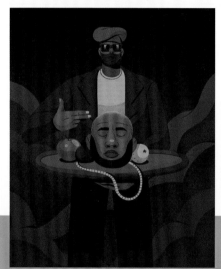

Due to the wide range of projects you take on, how do you decide who works on each project?

Each of our 12 team members has a different skill set and focus, so assignments are based on what the project requires. If a client comes to us with a very clear direction in style, inspired by something we've done before, then we make sure the person whose work was referenced has a heavy hand in the project. Alternatively, when we receive a project that requires visual direction from us, we work up a few "style tests," with the work going to the team member whose style test resonates most

with the client. We have such a varied mix of folk in the studio, so there's always a chance to put together different approaches and get different opinions on potential work.

You worked on a large collaborative piece called *One Last Song*. Could you tell us a little about the project and if there were any challenges along the way?

One Last Song is a fantastic book written by Mike Ayers, in which he invited 30 musicians to consider what song they would want to accompany them to the pearly gates. We

created illustrations for each chapter, matched to the song chosen. It was challenging to pull out the relevant aspects of each piece and we spent a lot of time working through various possibilities. As this was such a personal subject matter, we wanted the musicians to feel we had truly captured the essence of each of their choices and the stories behind them. In the end, we went for a mixed approach, where some were portrayed quite literally and others had a more conceptual interpretation. Because we linked the styles and color schemes throughout the book, these various approaches still worked together as a cohesive collection.

Opposite page (top left):

From *One Last Song* –
Sam Beam of Iron & Wine

Opposite page (bottom left):

From *One Last Song* –
Run The Jewels

Opposite page (right):

From *One Last Song* –
Andre 3000

This page:

From *One
Last Song* –
The Decemberists

"We take full advantage of opportunities to do projects that sit outside our usual wheelhouse"

On the whole, you create quite bold and colorful designs. Was this a conscious decision or a general style that has developed over the years?

It's probably a bit of both. Muti's early work was all about boldness and color, and as that's what clients approached us for, over time it's become a recurring theme in many of the briefs that come our way. Thankfully, though, we see a lot of variety in the work we receive. We take full advantage of opportunities to do projects that sit outside our usual wheelhouse, and love the chance to work on more subdued, intricate work.

What do you consider to be most important when creating character designs?

The aspect we prioritize the most is personality. The pose, clothing, facial expressions, and even accessories or background elements all have an impact on how the viewer reads and understands the character's personality. It's immensely satisfying to render a character and have others immediately recognize and relate to them. You want the viewer to say, "Ah – yes! That's how the character moves, that's how they see the world and react to things."

This page: Stills from our animated short, *Los Magos*

Opposite page: Created for the Quaranoids series, showcasing different personalities in lockdown

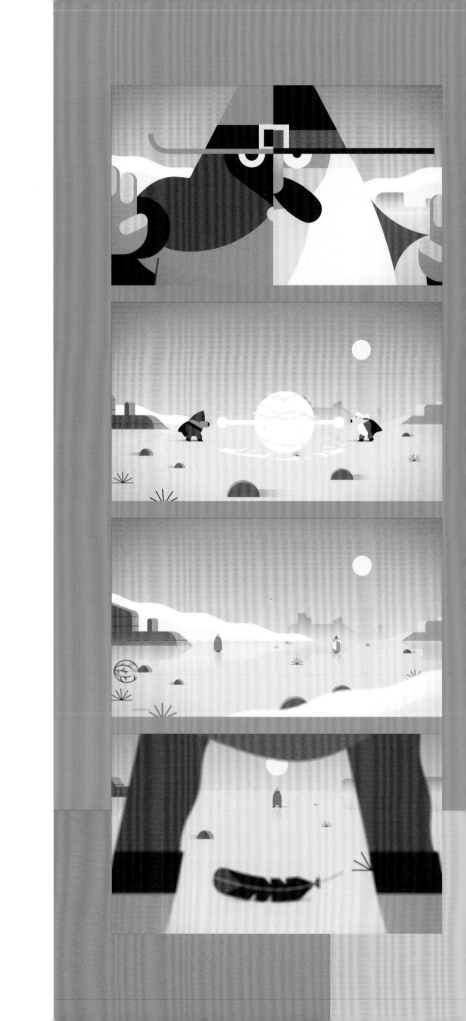

Which character-design projects are you most proud of?

We're particularly fond of our first animated short, *Los Magos*, which we finally released at the end of 2020 after it was accepted to a number of film festivals. It was our first foray into bringing our own characters to life in a longer format (well, longer for us!), and it was a great chance to collaborate with our team and work with some friends in the sound production field.

It's a 60-second animated short that we actually created way back in 2019. It depicts two sorcerers that come face-to-face to settle a quarrel, in a test of skill and strength in a desert wasteland. We didn't have any grand plans for the short – it started as just a fun in-house challenge to create something entirely from scratch. We sat on it for a while before deciding to try our luck, entering it into a few film festivals and releasing it online. So far, we've had a really positive response. We're well aware how difficult it can be to be accepted into festivals, so we feel very grateful to have been recognized.

Many people might associate design studios mainly with America or Asia – what is the scene like in South Africa?

There is so much talent in South Africa! There are many studios that focus on illustration, design, animation, and character design, and some of them are incredibly successful. Your readers have probably seen more things than they might have imagined that have come from South Africa's creative community. From time to time, we do get the opportunity to work with our fellow studios here and that's always exciting, but more often than not, we work on all elements of a project in-house.

What advice would you give to budding creatives who might want to join a studio like Muti?

Play, play, play! Keep trying new things, expand your skill-set, take influence from a variety of sources, and don't restrict yourself to only being inspired by other illustrators. Constantly mix and match skills and techniques to find where your strengths lie, and how best to use them. It's a good idea to learn how to be flexible in terms of style, but try to always hold yourself to a higher standard of consistent quality. Flexibility and high standards are two things we look for in portfolios from potential employees.

When it comes to character design generally, it's all about playing around. People don't realize how much they can learn from their own faces or people around them. Pull faces, move around, observe people at home or out and about – this will help you understand how your character moves and poses. We also find that our most successful designs start with an idea with a back-story or wider context. So, try to develop a story for your characters to really understand them.

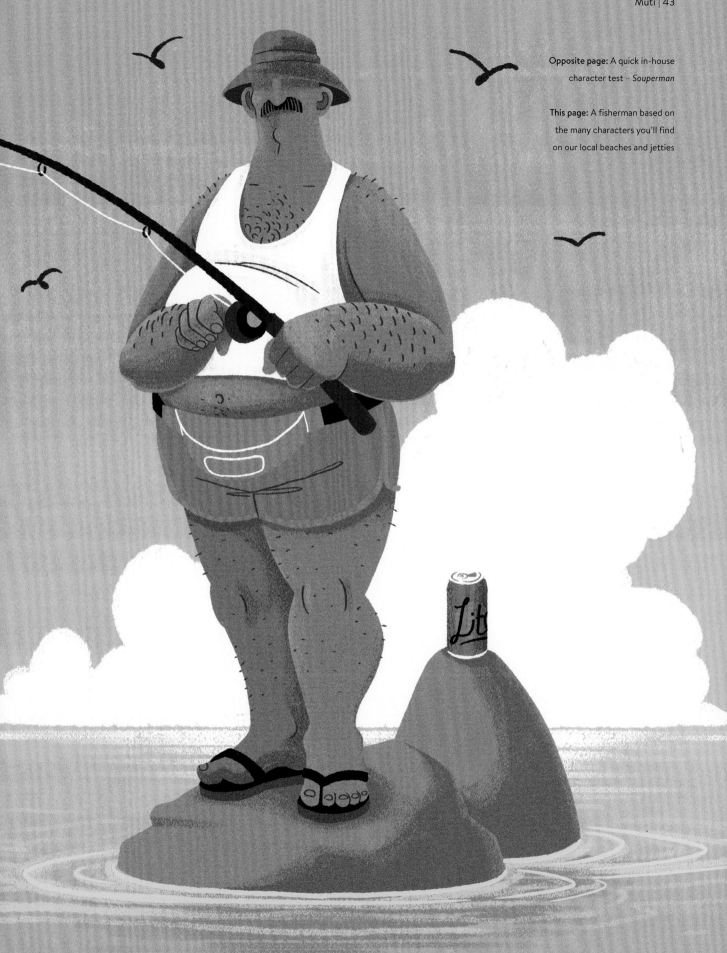

Opposite page: A quick in-house character test – *Souperman*

This page: A fisherman based on the many characters you'll find on our local beaches and jetties

LIGHTEN UP!
LYNN CHEN

The use of light is invaluable when telling a story in your designs. It's important to know how to design lighting scenarios and use color temperature, pushing warm and cool light to enhance the overall mood of your image. I will show you how to set up simplified lighting structures with key light, ambient light, and bounce light, to help you start sculpting forms. I've used Photoshop, but the same techniques can be applied to any software.

Spine direction (action line)

Connections

Joints/ Skeleton

INSIDE/ OUTSIDE

When creating illustrations, a solid base for your design goes a long way, so it's necessary to learn and analyze your subject's anatomical structure first. Even stylized characters benefit from this – it helps the design look more believable, especially if the character needs to be animated. One of the easiest ways to achieve this is to use the "inside/outside" method. To do this, you need to simplify the "inside" by imagining the skeleton within the body and locating the spine – this is your "line of action." Then sketch the "outside" forms to create dynamic gestures. Once you have established this basis you can refine the sketch, but at this stage still keep it loose.

Spine

BLOCK IN SHAPES

In this image, I use neutral colors to block in the shapes, with each color on its own layer. I add in some details and secondary characters to create a story and make the image more interesting. Remember, when choosing to add details, that they should complement the main character and not be too distracting. Keep flipping the canvas back and forth to check the balance of your design.

LIGHTING PLANNING

Before you start painting, it's a good idea to plan out your lighting setup. Break down each light source and assign them a warm or cool color. For example, in this particular design the sunlight and bounce light are warm and the fill light is cool. Try designing lighting with different temperatures coming from opposite directions – this will create volume and make the image appear three-dimensional. There are other things to consider, such as overcast lighting where the colors are mostly neutral, but even then you can paint in subtle color variations so that the colors appear rich rather than plain gray.

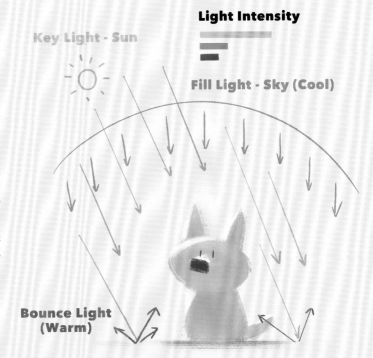

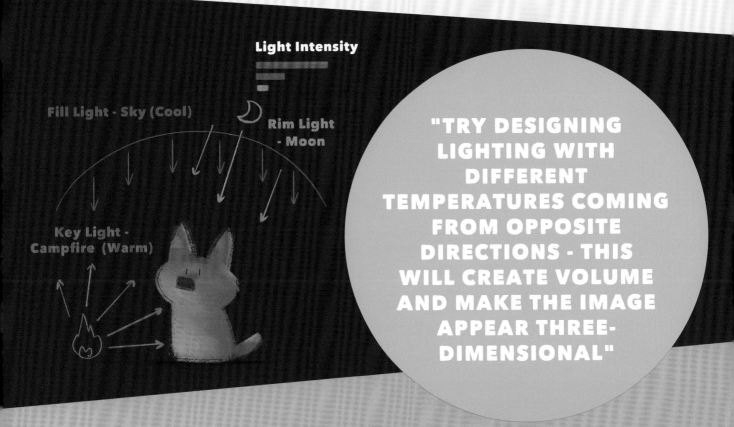

"TRY DESIGNING LIGHTING WITH DIFFERENT TEMPERATURES COMING FROM OPPOSITE DIRECTIONS - THIS WILL CREATE VOLUME AND MAKE THE IMAGE APPEAR THREE-DIMENSIONAL"

COLOR PROOFING

Painting light directly, without referring to a black-and-white thumbnail, can be difficult, as the values (light and dark) can get lost during the painting process. To avoid this, it's crucial to use grayscale mode to check your values throughout the process. This can be easily done by "color proofing" within Photoshop. Go to Menu > View > Proof Setup > Custom. Then, under "Device to Simulate," choose "Gray" and click OK. Now you can toggle between normal and grayscale color proofing by pressing CMD or CTRL + Y.

SCULPTING WITH LIGHT

Building on the base colors, start painting in one light at a time. The blue light comes from the sky, so all the surfaces facing upward will be affected by this light. To achieve this affect you can shift the local color toward a brighter, cooler color and apply it on all these surfaces, giving the appearance of being lit from above. Then move on to the secondary light source, and so on. This way, we can focus on the forms and have fun "sculpting" the character.

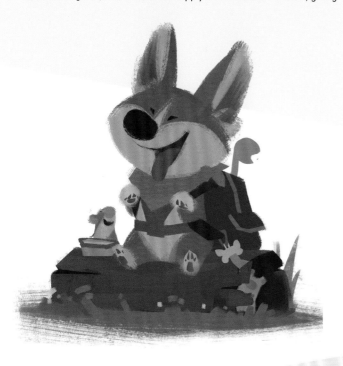

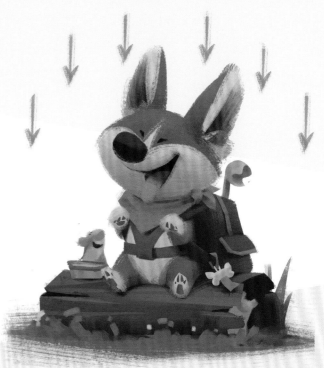

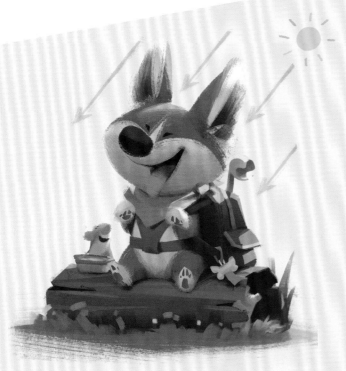

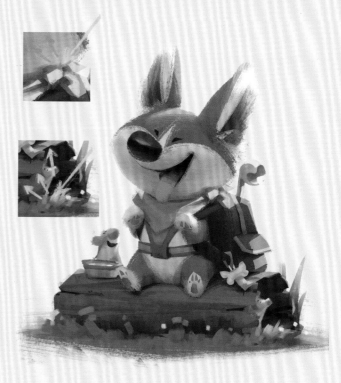

STAY BALANCED

When it comes to adding a background to your image, be aware of maintaining good contrast between busy and less-detailed areas. In this case I have blurred the background so the eye is drawn to the character. Try to avoid having very detailed backgrounds, as your character may get lost in the scene. Adding some simple details, such as a blade of grass peeking out from behind a log, will help establish the environment without going overboard.

PUSH COLOR TEMPERATURE

When selecting colors to represent warm and cool light, try using a LAB color picker instead of HSB. Visually, it is a more straightforward way of selecting warmer and cooler colors. As long as each color has a similar amount of color shift, the light will look consistent across the image. In Photoshop, the panel shown appears when you select the foreground color – I also have a shortcut set up for this panel for easy access when painting. Give it a try!

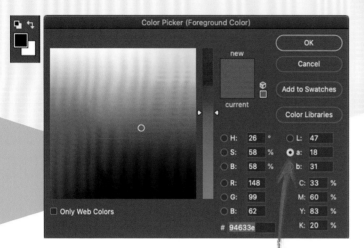

Choose "a" in LAB color panel

LAB COLOR:
Lightness, A-axis (green to red), and B-axis (blue to yellow)

HSB COLOR:
Hue, Saturation, and Brightness

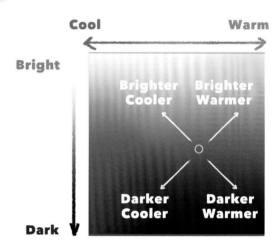

Local Color

Brighter Warmer

Warm Light

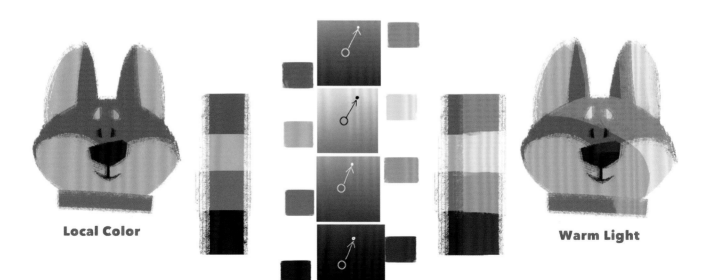

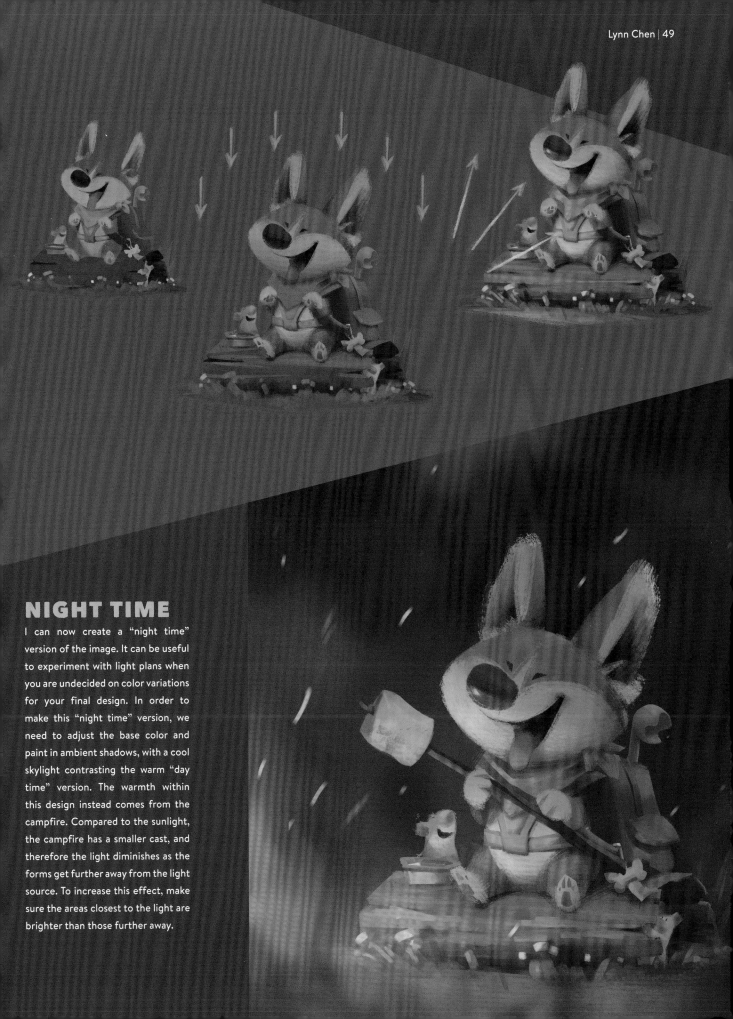

NIGHT TIME

I can now create a "night time" version of the image. It can be useful to experiment with light plans when you are undecided on color variations for your final design. In order to make this "night time" version, we need to adjust the base color and paint in ambient shadows, with a cool skylight contrasting the warm "day time" version. The warmth within this design instead comes from the campfire. Compared to the sunlight, the campfire has a smaller cast, and therefore the light diminishes as the forms get further away from the light source. To increase this effect, make sure the areas closest to the light are brighter than those further away.

What happens in Vegas...

SHANNON HALLSTEIN

When we were little, my sister and I would spend hours together, thinking up our own stories and characters. We wanted to see them live and breathe, so we would draw them in comic form as a way to experience their world for ourselves. This is the power of being an artist – being able to bring fictional characters to life.

In this tutorial, I will give you some insight into my creative process while creating a cast of characters – in this case, "a group of unlikely criminals who hit the Vegas strip." We'll dive into some research, generate thumbnail ideas in Procreate, and create interesting designs to work within our brief. These steps don't need to be followed to the letter, as every artist works differently, but can hopefully guide you into developing your own process.

Get the intel

With any brief, you need to get to know your subject before you start designing. You can do this by looking at comics, movies, or novels that have already approached the subject in some way. Try to get a good variety of sources in order to bring the most helpful aspects to your designs. Sometimes I find it best to just go in a certain direction, even if I'm not sure it's the right one. You can sometimes only find out if a path is wrong by first going down it. That's why I don't like to waste *too* much time thinking before I start drawing.

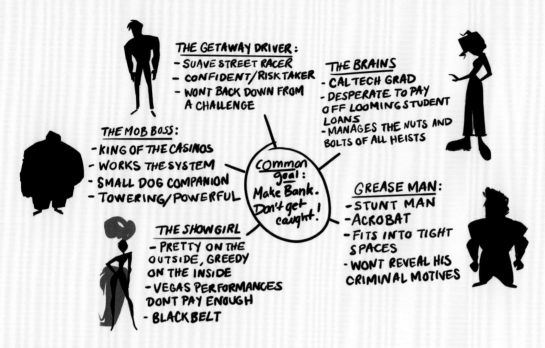

THE GETAWAY DRIVER:
- SUAVE STREET RACER
- CONFIDENT/RISK TAKER
- WONT BACK DOWN FROM A CHALLENGE

THE BRAINS
- CALTECH GRAD
- DESPERATE TO PAY OFF LOOMING STUDENT LOANS
- MANAGES THE NUTS AND BOLTS OF ALL HEISTS

THE MOB BOSS:
- KING OF THE CASINOS
- WORKS THE SYSTEM
- SMALL DOG COMPANION
- TOWERING/POWERFUL

Common goal: Make Bank. Don't get caught!

GREASE MAN:
- STUNT MAN
- ACROBAT
- FITS INTO TIGHT SPACES
- WONT REVEAL HIS CRIMINAL MOTIVES

THE SHOWGIRL
- PRETTY ON THE OUTSIDE, GREEDY ON THE INSIDE
- VEGAS PERFORMANCES DONT PAY ENOUGH
- BLACK BELT

This page (top):
Make a quick research list for each of your characters before you start

This page (bottom):
Thumbnails exploring shape and silhouette for my five characters

Lay out the blueprint

When starting to create your thumbnails, make sure you take the thoughts you've had and the research you've done into account. At this point your ideas are rough and nothing is set in stone – this is the "unattractive" stage, so don't worry about the details. In order to stay loose, I like to work with a large brush in grayscale, which keeps things focused on the silhouette. This helps you pay attention to the proportions of your characters and the use of negative space within each thumbnail. Thumbnails should be quick sketches, as they are purely exploratory and not for the whole world to see.

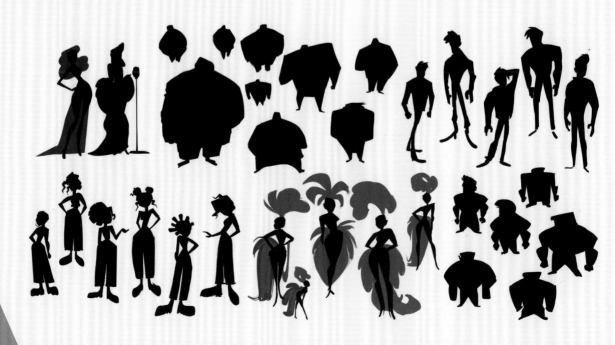

"Reinventing tropes can make your work stand out and bring new ideas to the table"

CHARACTER TROPE: NERD
- HUNCHED POSTURE
- GLASSES
- CAFFEINATED
- PULL UP SOCKS AND PANTS
- TIRED EYES
- BACKPACK OF SCHOOL SUPPLIES

CHARACTER TROPE: THE SCHOOL JOCK
- BOISTEROUS POSTURE
- PERFECT HAIR
- CLEAN CUT CLOTHES
- FOOTBALL PLAYER
- TEAM CAPTAIN

The usual suspects

Having a basic knowledge of character tropes is helpful when designing, so you know what's been done before. There are certain character tropes that can trigger presumptions from the audience. For instance, a large muscular character can be seen as intimidating or powerful. Here, I've drawn two examples of characters that are easily recognized by certain characteristics, to showcase how using character tropes within your work can reinforce their believability or be inverted to create something new. For the "Mob Boss" character, I want to contrast this large and intimidating man with a small dog companion to give him a softer side. Reinventing tropes can make your work stand out and bring new ideas to the table.

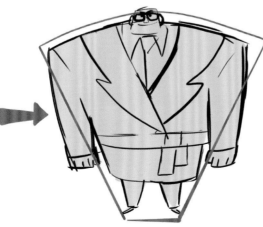

A little razzle dazzle

Don't be afraid to push the proportions of your design and do several iterations of one thumbnail. It is better to exaggerate your designs and pull them back in, than to go too simple and not be able to exaggerate at all. Try to avoid parallel lines and shapes of the same size in your design, as these can be dull to look at. By pushing and pulling the shape and size of your thumbnail, it will lead to a stronger and more appealing design later in your process.

Ideas trashcan

In the earlier concepts of my showgirl character, I pictured her as a casino singer. After some consideration, I felt this was a little too dull and wanted a more exciting version to spice things up.

Assemble the crew

For this particular brief, we are designing multiple characters, so it's important to consider how they look together as a cast. The best time to do this is during the thumbnail stage. Pay attention to how the characters use negative space and whether there is enough contrast between shape and size. If they feel too similar, try going back and pushing the size relationships between the characters, to create some variation. Contrast creates interest, so by having differing personalities and designs, you will create a more engaging cast of characters.

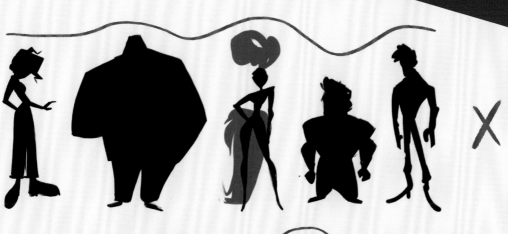

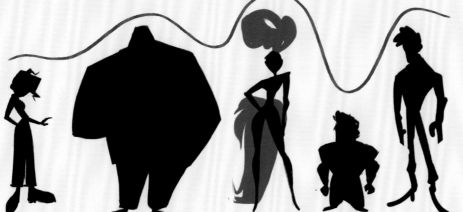

Opposite page (top):
Showcasing common character tropes and their recognizable characteristics

Opposite page (bottom):
Exaggerate the proportions to avoid dreary designs

This page (bottom):
Create interest by using contrasting shapes and sizes throughout your line-up

Do the math

One simple equation can be used to help bring visual interest to your design. That is: *curved + straight = interest*. Typically in design, sharp angles and points are used to represent villainy, as they heighten the dangerous and aggressive character tropes. Straight lines lead the eye quickly, while curved lines slow it down by reiterating the volume and flesh of your character. It is important to pin-point the areas where you want to add interest, as you can then determine whether you need to add straight or curved areas to add balance. Using a combination of these lines will enhance your design's appeal.

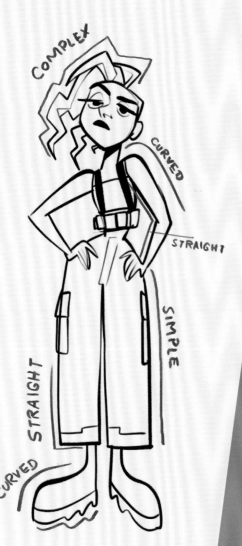

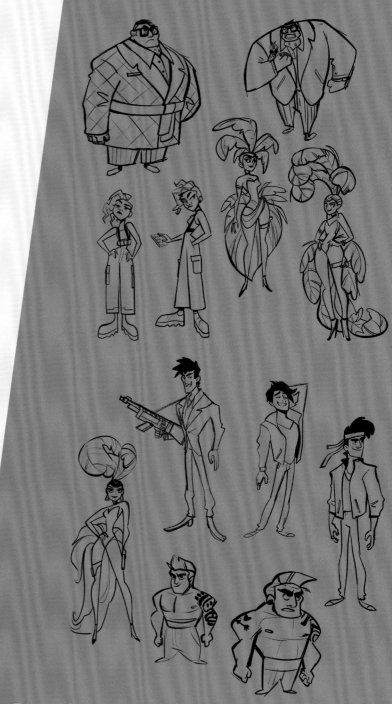

The finer things

Once you have your proportions set and your characters working together, it's time to start refining your designs. When working digitally, you can set your thumbnails to a low opacity and sketch right on top of them. With every step, you can see which parts of the design are more successful in terms of silhouette and shape language, allowing you to hone in on the aspects that work best. When adding details such as props, it can be easy to go overboard, but this can distract the viewer. Try adding a couple of small elements that will help highlight the character's personality, and aim to make a recognizable and clean design. Simpler character designs allow the audience to impose their own references on the character, which increases their appeal.

Strike a pose

Once you've developed designs that you're happy with for each character, you want to pose them in a way that will reflect their personality. Posing your character can help your audience find something in your design they can relate to, which is one of the most important tasks of a character designer. A great way to discover pose references is to enroll yourself in a life-drawing class, or you can simply head out to a busy spot and people-watch. You will find it's pretty easy to pick out personality types by the way people are posed, and you can transfer this to your characters.

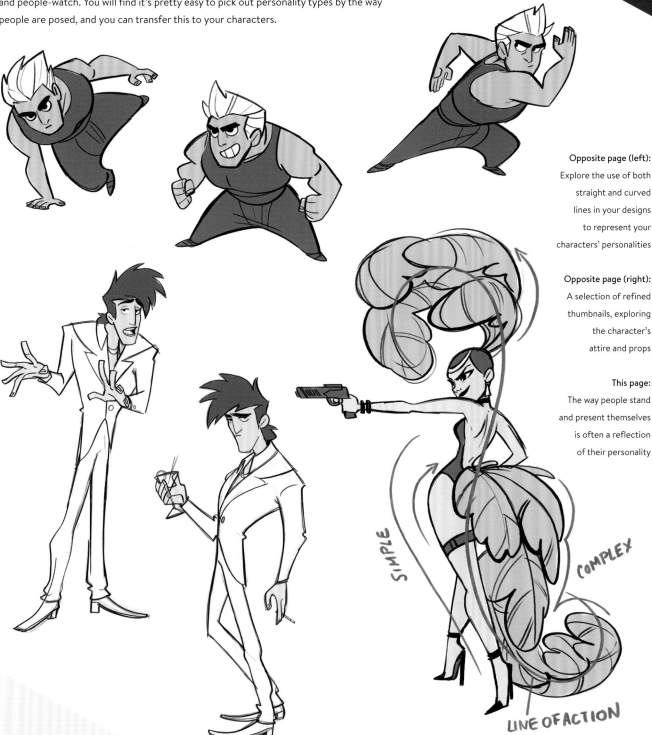

Opposite page (left): Explore the use of both straight and curved lines in your designs to represent your characters' personalities

Opposite page (right): A selection of refined thumbnails, exploring the character's attire and props

This page: The way people stand and present themselves is often a reflection of their personality

SIMPLE

COMPLEX

LINE OF ACTION

Inner workings

Another crucial aspect to character design is understanding how your character is built "under the hood," especially if you are creating characters for CG productions, where characters will need to be rendered by 3D modelers. Even if your character is covered by clothes, taking the time to figure out how they fit together underneath will save time and effort when your design reaches the animation stage. My advice is to take advantage of those life-drawing classes – if you build a solid understanding of anatomy, you can create more believable and well-constructed characters.

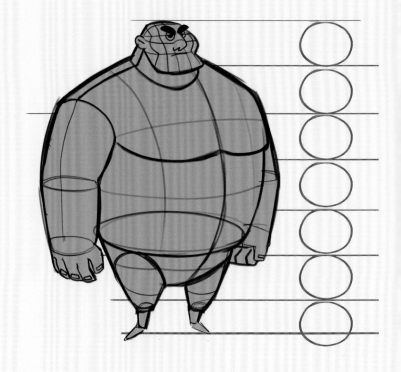

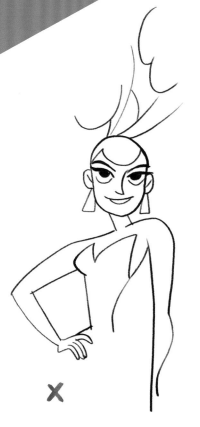

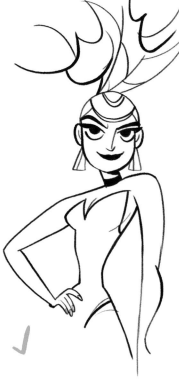

Keep it dynamic

Sometimes, drawings can lose their dynamic qualities if overworked. They can start to feel robotic or stiff, far removed from the original sketches in the exploratory stage. Try to find areas of your design where you can enhance the "rhythm" to help bring the appeal back. It's okay to break some natural rules here and there, as long as the design still feels believable.

This page (top): Having an understanding of your character "from the ground up" will help you pose and present them in an effective way

This page (bottom): After refining your thumbnail, you may need to go in and add some movement

Opposite page (top): Explorations of facial expressions

Game face

Generating multiple facial expressions for your character showcases their personality and their range to potential animators. One of the easiest ways to create different emotions on the face is to squash and stretch the face shape, while retaining the anatomical structure. You can use photo references to help you generate specific emotions, or use a mirror and your own face. When I create expression sketches, I like to include the top section of the torso and the shoulders, as this enables you to express body language in line with the emotion you want to portray. Make sure you keep the expressions interesting by drawing the face from different angles, avoiding symmetry on the page.

Work smarter not harder

In this digital age, it's more important than ever to stay organized and updated. When you work digitally, keeping track of files without organization can be exhausting and time-consuming. By making the time to organize your workspace, and naming folders and layers in Photoshop or Procreate, you can save yourself a headache later. Use cloud storage services to keep track of your progress if you work over multiple devices. Even if you sketch traditionally with pen and paper, you can scan or photograph your work and store it digitally.

Getting colorful

When I start to incorporate color into my designs, I want them to enhance the design, not overshadow them. The colors you choose should bring your characters to life, and reinforce all the hard work you've put into establishing their personality. You can use color to direct your audience's attention by creating focal points that are brighter and more saturated than other areas. Your color choices should follow a harmonious palette, so try to explore hue combinations that reiterate your character's personality – unless you want your character to appear discomforting, in which case you can choose colors that create tension.

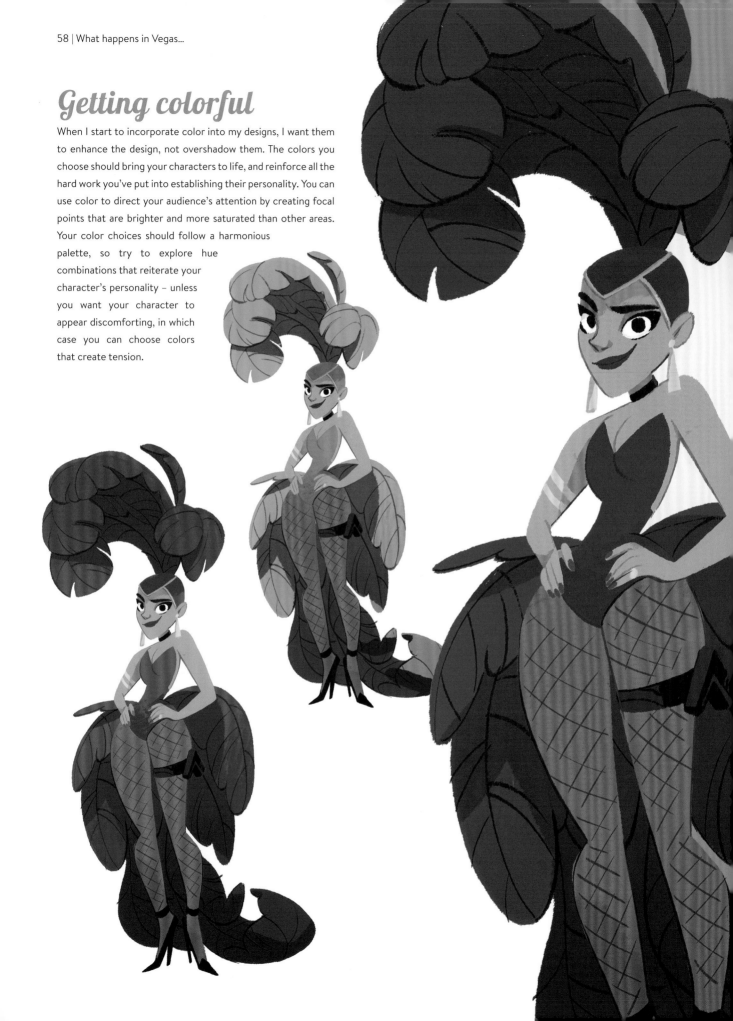

"Adding a small amount of texture throughout can bring some interest to your design"

Value and contrast

Once I've made a decision on the color palette for my characters, I like to go straight in to coloring, rather than setting values in black and white first. I check my values along the way by switching to grayscale mode in Photoshop, to see whether each element of the drawing is reading strong and to check there is enough contrast within the design. Adding a small amount of texture throughout can bring some interest to your design; just ensure you don't lose the focal points by adding too much detail.

Opposite page:
Explore hue combinations that are right for your character

This page:
Use grayscale mode to check your values and contrast as you color

Where to look?

Eye direction is a very important consideration and can convey a huge amount of emotion in your character's expressions. This is especially true if two or more characters are intended to be interacting with one another. Using your characters' eye direction can help reinforce relationships with other characters, their surroundings, and the viewer.

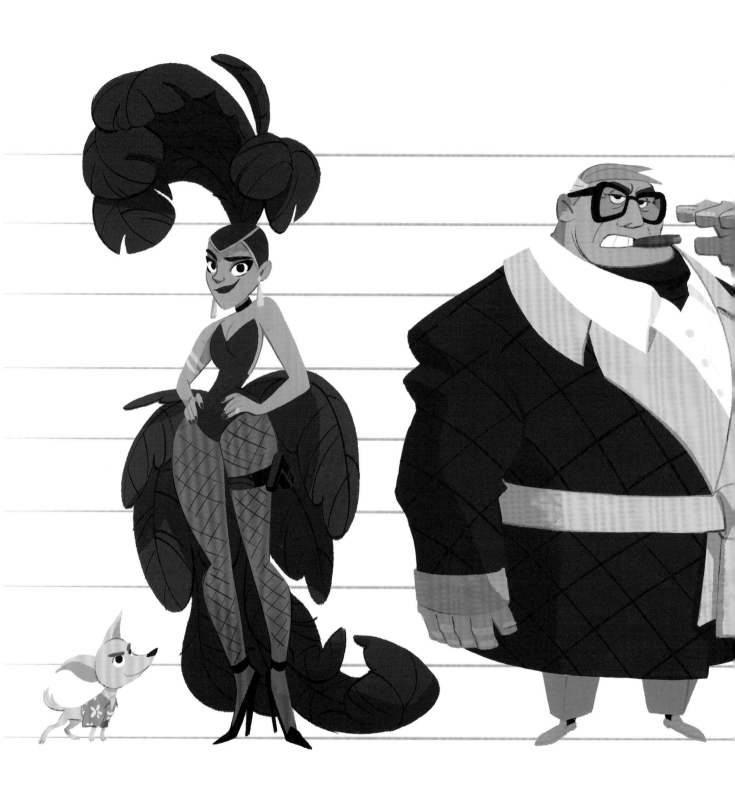

This spread: Our cast of unlikely criminals are ready to hit
the Vegas strip. Final images © Shannon Hallstein

The line-up

Now I add the final touches, such as texture and lighting, and extra details like wear and tear to the character's clothes. Be cautious – these details need to support your character's story without overwhelming your design. Your design is the primary focus for the audience, not dazzling colors or shading. Feel free to have fun with this stage, though, experimenting with different accessories and details until you find the combination that builds on your design and makes it stronger.

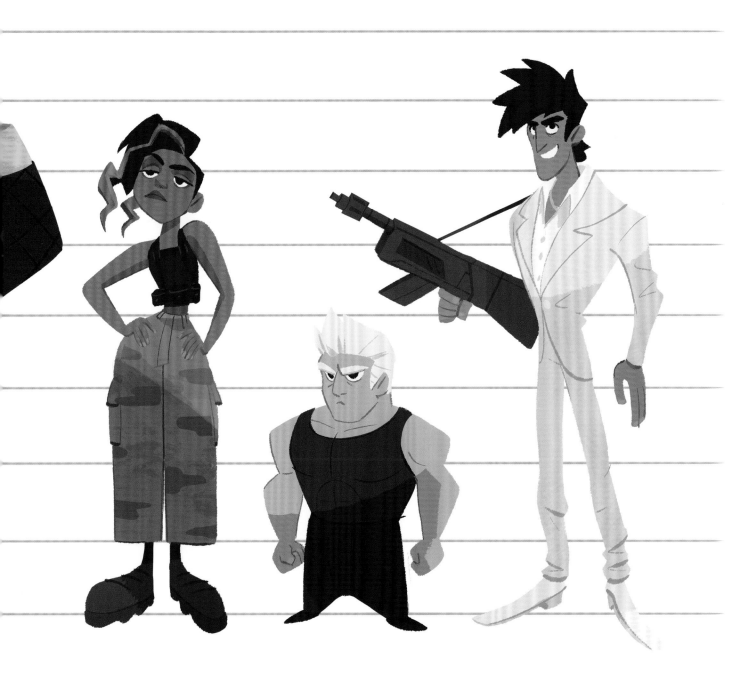

ARTIST CATCH-UP:
AMANDA JOLLY

We last chatted to character designer Amanda Jolly way back in the very first issue of *CDQ*, so we thought it was time to catch up with her again and find out how her career has developed over the last few years. We spoke about her exciting time working at Disney TV and her current role at Netflix Animation, asked for her invaluable advice for budding character designers, and much more!

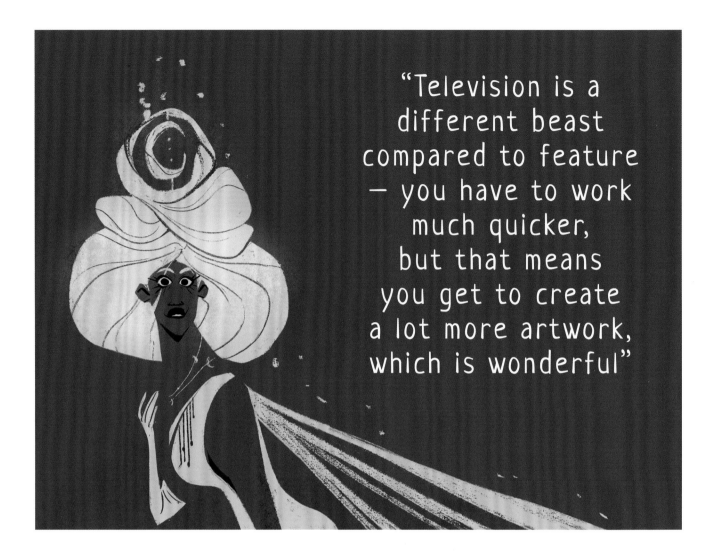

"Television is a different beast compared to feature — you have to work much quicker, but that means you get to create a lot more artwork, which is wonderful"

Hi Amanda, thanks so much for chatting to us again. Could you tell us a little about yourself and what you do?

Hi guys! It's great to be talking with you again. So, I'm a character designer in feature and TV animation. And while I grew up loving animation and wanting to join the industry, I detoured and got degrees in entirely unrelated subjects before professionally pursuing art. I think I believed that other fields would result in more "safety and security." Having a career in animation simply felt intangible. However, America's Great Recession left me with a complete absence of job prospects, so I shifted gears toward my passion – I enrolled at Art Center College of Design to receive an actual art education. That change was the absolute right move. I left three years into the degree, as Sony Pictures Animation offered me a job. Even though that meant not graduating, I jumped at the chance, since, really, who *wouldn't* rather be getting paid than paying money? Jokes aside, the opportunity was amazing, and best of all, I got hired straight-out to be a character designer, which is a pretty competitive field. It's also the only thing I've ever wanted to do.

What kinds of projects have you worked on since we last spoke?

I believe when we last spoke I was moving into TV character design for the first time, which was super exciting. I had wanted a change of pace at work, and I was lucky enough to get tapped for *Rapunzel's Tangled Adventure* at Disney TV. Television is a different beast compared to feature – you have to work much quicker, but that means you get to create a lot more artwork, which is wonderful. However, we wrapped the show a little over two years later and I got the itch to return to feature animation. In the last few years I shifted back to Sony Pictures Animation, the studio where I started my career, to work on some big-name projects. And now I'm over at Netflix Animation working on an original feature – and it's *so good*. The project itself is a dream in terms of my personal interests and goals, which is a rare opportunity. Combined with working as part of a wonderful, supportive team, I feel very lucky.

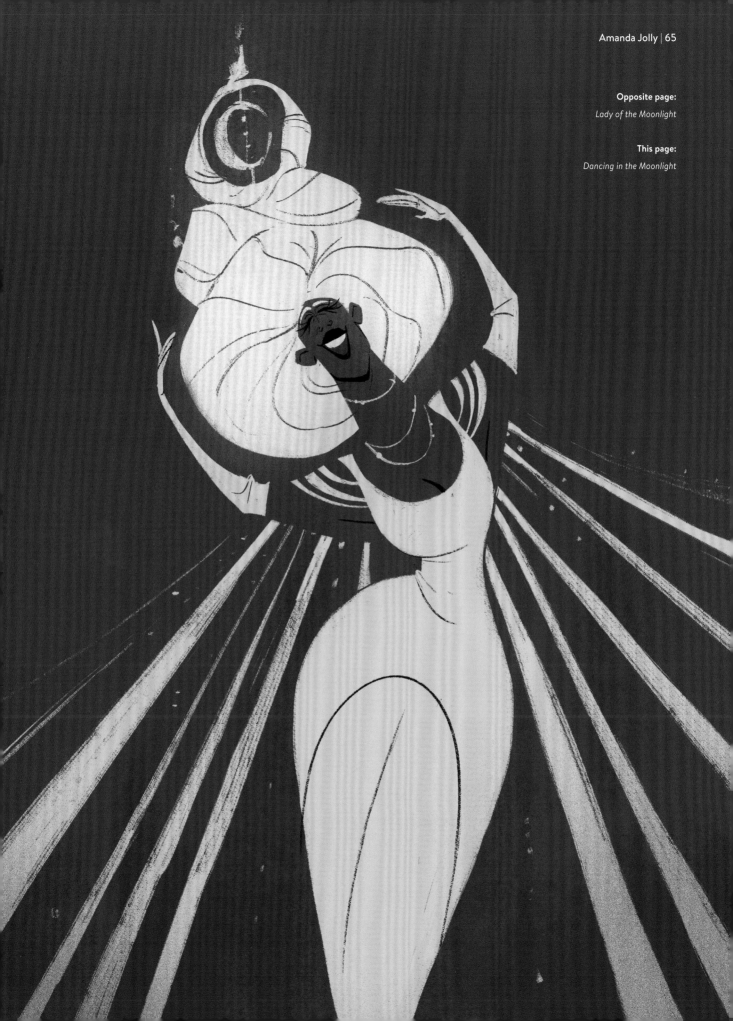

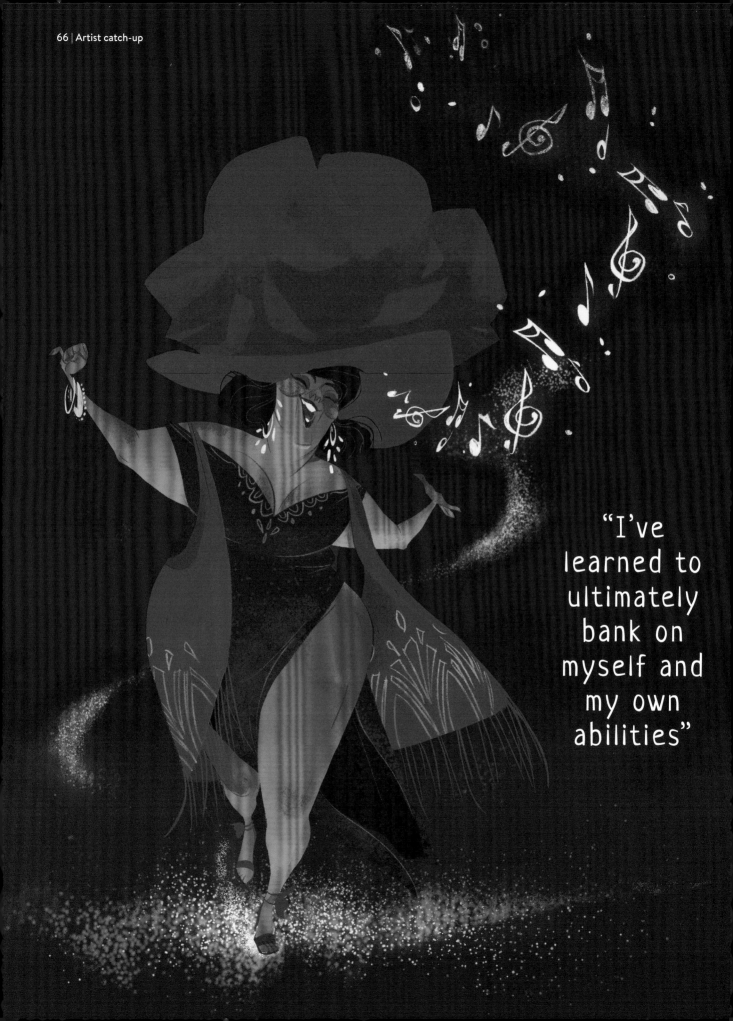

"I've learned to ultimately bank on myself and my own abilities"

Is there anything new you've learned or discovered about your own creativity or the industry?

As you progress, you find you are always learning about yourself as an artist and the field you work in. One thing I've discovered is how much I value not only style, but the teams I work with. When I started out, I was most concerned with being a part of stories that would be timeless and touching, but I've learned when you take a project on, it's hard to know if it will be successful. Now I'm more concerned with choosing projects where I get to create art with people I enjoy seeing daily – having a fun time making it makes the process far more enjoyable.

I think I've also learned a lot about personal resilience. I've had a lot of good fortune in my career – the kinds of projects I've ended up working on as well as the people I've worked with – and for years, that fortune created a pretty charmed outlook. However, the longer you work and the more shows you're a part of, the more you start feeling the churn of the industry – that you'll always be moving on or moving forward, that you'll continually have new work dynamics or new styles to interpret. That can sometimes drain you or throw you for a loop, so I've learned to ultimately bank on myself and my own abilities, and to try to stay true to what's most important to me.

Are there big differences in how different studios and companies operate? Which methods have you found the most successful?

Not only is there a difference between studios, but also between projects within each studio, which makes it difficult to generalize that one company has a particular way of doing things. The majority of the differences come from the team you work with and the projects you're working on. But there are some things worth noting about some of the companies I've worked for.

At Disney the idea of magic is permeated throughout the brand, and you can really feel that when you're there. They have such a wide reach, so you feel like you are touching a lot of people, which makes it very exciting to work on a project with them. In comparison, during my time at WB, the feature department was so small that we felt like a team of underdogs, but it was an enriching and empowering time for me. We all had to work so hard in the best way – I constantly surprised myself, and the team had a lot of trust in me. It was a very satisfying project to work on. Now I'm working at Netflix and, although I haven't been there for very long, it's an entirely different experience. It feels very much like a creators' company. Every day it feels like *we* are making the decisions and we're following *our* vision. The studio is concerned with respecting and protecting the creators' vision, and I think it shows.

Despite these differences, I've found that what makes a successful experience is the same across the board, and that's finding a team you mesh with and that respects your time and voice. The best teams I've worked with give clear direction and offer lots of support, while also valuing my time as an artist and a person. I've created the best work and been happiest when I've been given this level of support.

This page:

Sing the Song in Your Heart

Opposite page:

She Comes From The Trees

One of your most notable credits is working on the successful *Tangled* animated series. How did you find working on established animated characters?

The show and the team I worked with on *Tangled* will remain a highlight of my career. It was such a positive experience, and it allowed me to win an Annie Award, no less, so that's pretty hard to top. As for working with existing characters, I loved it because I felt I had a good understanding of the kind of people they were. I joined the show in its second season, so the style for the show had been established. That said, I was given so much freedom to try things and test out new characters. I could design how I wanted and then fit those designs into the show's style later on. It was a really refreshing experience.

What would you say are the major differences between working on ongoing animation projects and one-offs such as movies?

The biggest difference is probably something people wouldn't expect, which is the organization and timing of production. A TV show has to frequently churn out content, so deadlines are real and constant. If the show is well-run, that means you design quickly and effectively and everyone has to sign off on designs in a timely manner to keep the machine running. However, in feature animation there is often a lot of wiggle room time-wise, and designing can go on for months. This extended time period allows designers to reiterate designs for a second, third, or fourth time, and the process can drag as people search endlessly for the "right" thing. Sometimes, that can be exhausting, but it can also be extremely rewarding when you finally "crack it." I feel like I really know my characters inside and out when I work on them for a feature – they are fully realized.

This page:
Well Educated... In Murder

Opposite page (top):
The Femme Fatale Herself

Opposite page (bottom):
Big Game, Big Trouble

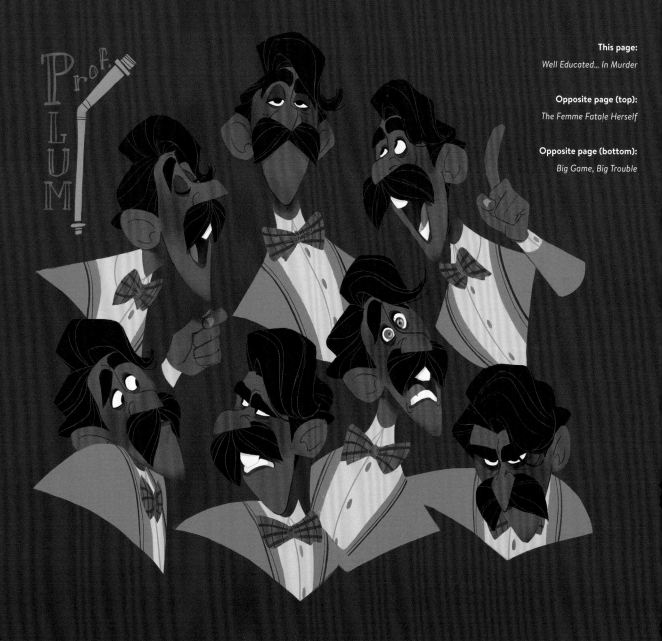

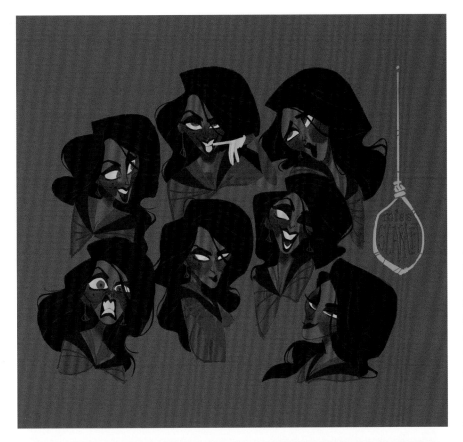

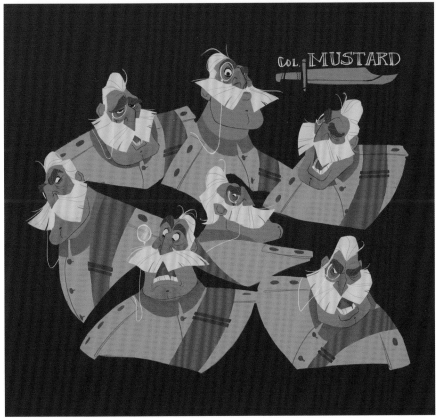

"So much is different and so much is oddly the same"

Another difference which is often overlooked, but worth noting, is an audience's presence while you are creating the product. When you design for feature, there's a large time period between when you make something and when an audience will see it. With TV, however, you're still working on a show while the audience are receiving it. We were cranking out seasons 2 and 3 of *Tangled* while audiences were consuming the first, and I felt such a connection with our audience because of it.

How has the pandemic changed how you work, if at all?

So much is different and so much is oddly the same. The actual working experience hasn't been so different for me, and I actually love working from my office space at home (mainly because of my secret stash of chocolate!). However, the experience communicating with colleagues is entirely different. When you're in an office, you go out to lunch, hang around people's desks, and get to know the people you're working with personally. Covid has limited my time with people to video meetings or phone calls, and that's a difficult thing to adjust to. I've still managed to establish a couple of good, new relationships, even in this environment, but I do miss rolling into other people's cubicles and talking about nonsense.

What do you consider to be the most important skill to have when working in character design?

I have two things I consider paramount for character design – listening, and digging into the character. Listening is important, as you have to pay attention to the initial and changing needs of your leadership. Your job is to fulfil their vision and be able to make adjustments when those visions inevitably change. "Digging into your character" helps work out how you perceive your character as a person. Someone may give you a brief to create a "pretty girl," for example, which doesn't really give you much to go on. However, if you can gain more information about her, such as her role, background, and how she acts – then aspects about her character, even down to her outfit choices, will seem much more specific and real.

Do you have any advice for our readers who want to get into the industry, or want to go further?

Always keep your eye on what the industry standard looks like. I often hear from people who have worked for years but haven't been able to break through, and then when I see their work, I realize it's not at industry level. Unfortunately, time and effort alone aren't the keys that fit the animation lock – you have to be able to do the job at the level of people that already have it. So, look around with a keen eye at the work of current professionals and strive to get your work up to that standard.

What kinds of projects are on your horizon?

At the moment, I am fully focused on the Netflix show. As a team we have the potential to make something unique and special, and it ticks many boxes for me. Often in this business, you go where the openings are, and if you're fortunate enough you may have a choice between one or two jobs. It's quite rare to come across a project that fits, but that's miraculously what I'm doing – and now I've got a taste for it, it's making me hungry for more! I would love to be able to tell my own stories and highlight the kinds of people I want to be seen. It's a gift to have a group project that resonates with your individual voice and values, and I've got the itch to realize this potential even further. Writing has also been a lifetime love of mine, so perhaps I can channel that to create stories to reach people. Then I'd be at my very happiest.

This page:

"One Day This Will All Be Yours"

Opposite page:

She Paid a Lot for that Kelp

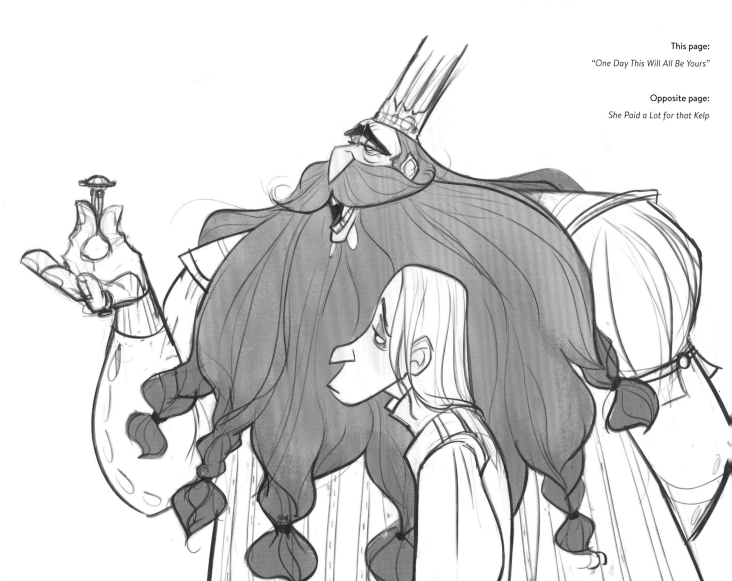

"Always keep your eye on what
the industry standard looks like"

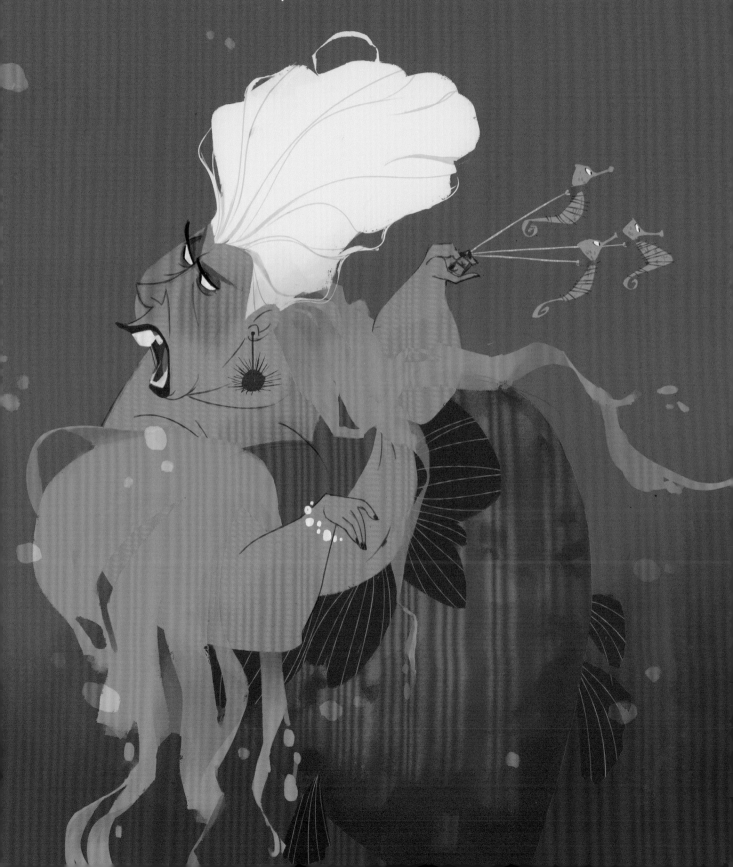

EXPRESSING EMOTIONS:
POWERLESS AND BRAVE

RAQUEL OCHOA

It is so important to convey emotion through your character designs, to bring them to life and make them relatable to the viewer. Here I will show how I create characters expressing the emotions "powerless" and "brave," focusing on the important things to consider and demonstrating how to build body language and expressions.

POWERLESS

CAT'S CRADLE

To be powerless is to feel defeated or without ability, and this emotion affects the body by dragging it downward. So, to make our cat appear powerless, I draw the body with a concave curve to it, conveying the weight of the feeling on the body. I also draw the tail tucked in close to the body and tilt the head down, showing tiredness and uncertainty.

DOWN IN THE DUMPS

Now that we have established some signifiers of "powerless," we can translate them to our female character. Reflecting the downward curve of the cat, I draw the woman hunching her shoulder forward and lowering her arms. This helps show a lack of strength within the character as it visually draws the eye downward. Focusing in on the face, I pay attention to the curve of her eyebrows and mouth, and give her a downward gaze to further communicate hopelessness and exhaustion.

OUT OF SORTS

Now you can transfer these same characteristics to our male character, with some subtle variations. To help show an insecure and defensive attitude, I show him closing in on his own body. I use the arm to cover his body as a sign of helplessness, and lower his head. By combining this with a slack look upon his face, we evoke the feeling of powerlessness.

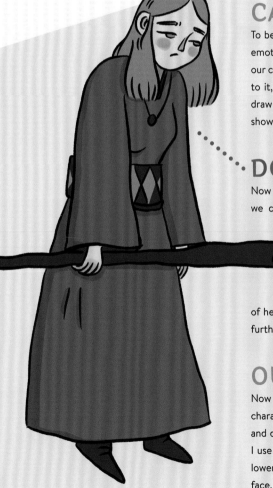

BRAVE

COOL CAT

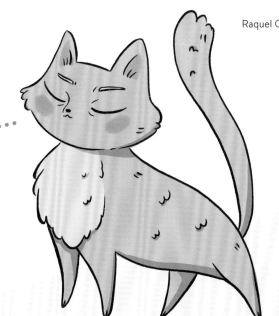

In contrast to "powerless," bravery is to be courageous and confident. To illustrate this within our character design, we need to contradict the body language of powerlessness and show conviction. We can do this by drawing the body in a convex position, with the face and chest lifted high. This position helps shows self-confidence and a provocative attitude.

GIRL POWER

For our female character, we want to pose her in a way that helps showcase bravery and self-assurance. By drawing our character with her foot placed on top of a rock, with a clenched fist, we are able to denote an attitude of action, in line with the feeling of bravery. This, combined with her high gaze, makes her appear confident and fearless.

MAN OF THE HOUR

In comparison to our powerless male, the brave male has a more open pose. I place his legs apart in an assertive stance, with his hands on his waist, to evoke feelings of security and bravery. His chin is tilted upward and his satisfied facial expression helps to indicate his confidence.

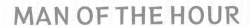

WORKING TOGETHER

Having the ability to successfully express emotion in characters is the goal of every character designer. Emotions increase the appeal of characters and help tell their story. The most successful way to do this is to ensure that both the facial expressions and body language are working harmoniously together. Having a strong reference image to work from can help – you can generate your own by posing and taking photographs, or prepare sketch studies from real life. This way, the audience will instantly recognize the emotion and be able to relate to your character.

THE CREATURE AWAKENS

RUDY HILL

For this brief, I was given the task to create a character design based on three words – heaving, creature, and destruction. In this tutorial I will show you how I approach the task of creating characters and dealing with problems that may arise. I'll provide you with some tips and techniques that will make your job of designing easier, and teach you how to produce good silhouettes and shapes to help your designs "pop." I will be using my XP-Pen Artist Display and Photoshop, but the techniques used can be applied to any medium. Let's get started!

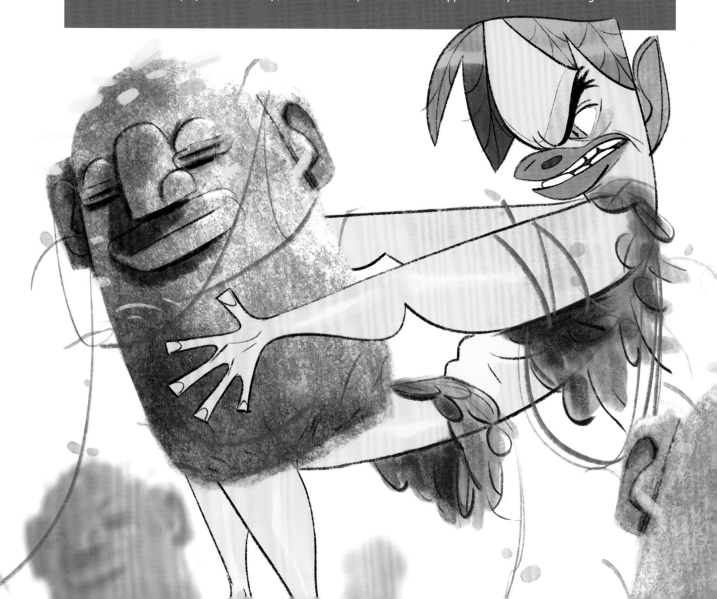

DO THE RESEARCH

In order to create the most convincing and appealing character designs, you need to get to know your characters well. The easiest way to do this is to squeeze as much information as possible out of each word provided to you in the brief. Once you get the ball rolling on the research, you will find that you begin to imagine what your character is going to look like. Having a vision of what you want to create will give you a clear path to go down, rather than stumbling over unnecessary details and wasting your time.

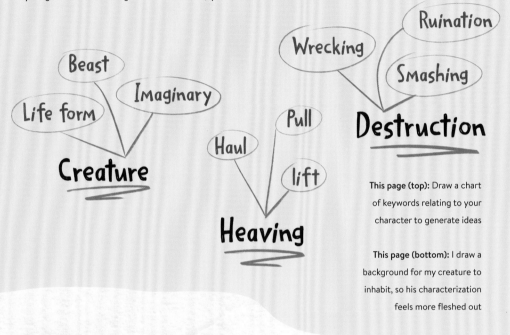

Beast
Life form
Imaginary
Creature

Haul
Pull
lift
Heaving

Wrecking
Ruination
Smashing
Destruction

This page (top): Draw a chart of keywords relating to your character to generate ideas

This page (bottom): I draw a background for my creature to inhabit, so his characterization feels more fleshed out

CREATING A STORY

Now you need to think about a good back-story for your character. The more information and details you have gained from your research, the more clearly you will see this story taking shape. Thanks to my three-word brief, I already have a vision for my character. It's an ancient creature that sleeps for many years at a time. Every time it wakes, it finds the land littered with human statues, and destroys them in frustration.

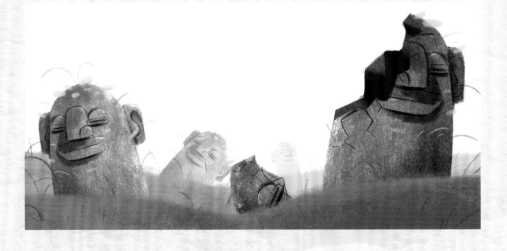

SKETCH OUT YOUR CHARACTER

Now it's time to start sketching thumbnails of your character. This is a stage for ideas – don't worry if the drawings aren't perfect, or if some of the ideas seem bad, just do quick sketches without too much detail. I know I want to include some plants and grass growing on top of my character, to help sell the idea that he is ancient and has been asleep for a long time. After some rough sketches, I land on a design with a good structure that I can build on.

This page (top): Use rough thumbnails to experiment with different shapes and forms

This page (bottom): Warming up

Opposite page (top): Experiment with different shapes and pick the ones that best suit your character's personality

Opposite page (bottom): Find a pose that clearly illustrates the emotion you want to portray

WARM UP

It's always a good idea to warm up your hand before drawing. I like to do this by drawing loose circles and spirals, as well as drawing 3D cubes from different angles. Taking the time to warm up will help you draw curved lines, and other shapes and forms, more confidently.

USING SHAPES

Shapes can hold a lot of meaning and help to tell stories, so they are an invaluable tool in character design. For example, a triangle with sharp edges can indicate danger, a square gives a sense of heaviness and stability, and curved shapes give a softer, friendly feeling. My chosen design has a good combination of shapes, and I feel confident they help sell the personality and story of my character.

HOW TO POSE

At this stage I try out different poses for my character. We want a pose that captures the right emotions and actions to help tell the character's story. I like the circled pose here because it expresses the physical strength I want the character to portray. I have used a mix of simple lines (shown in blue) and complex lines (shown in red) – this helps to create an interesting pose, while keeping the design clear and readable.

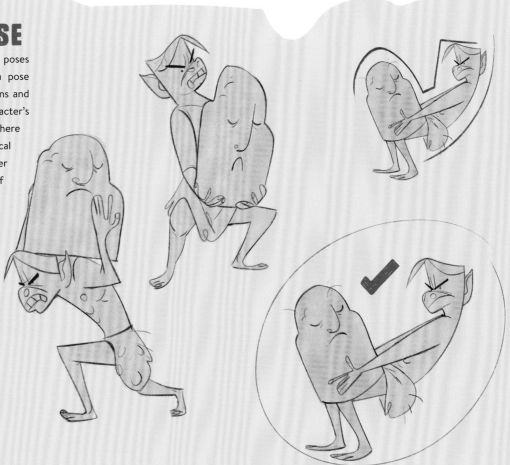

IDEAS TRASHCAN

Here's a selection of some of the designs I went through before I landed on my preferred creature. As you can see, I tried many different shapes and sizes, and at the time the back-story I had in mind was different from the one I ended up choosing. When I changed the back-story, that's when I scrapped these ideas and began focusing on the earthy creature I developed instead.

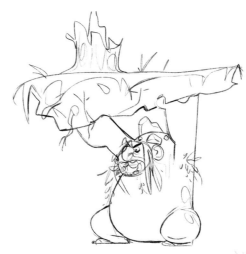
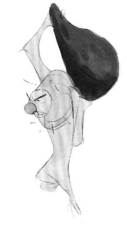

USING SILHOUETTES

Silhouettes are among the most helpful methods in design to produce a large quantity of variations of concepts. This method isn't used by all artists, and it's not essential to build your character up purely from a silhouette. However, it is important to focus on the shapes to create designs that have an immediate, strong impact on the viewer. Once I create the silhouettes for my image, I decide to separate the arms so there's clear definition between them. We often refer to a silhouette as a black, outlined shape, like a shadow, but this doesn't always need to be the case. You can create a similar effect by drawing a simple sketch or using one solid color.

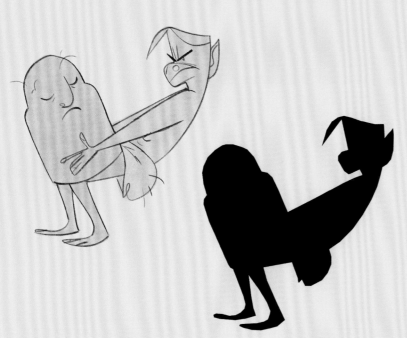
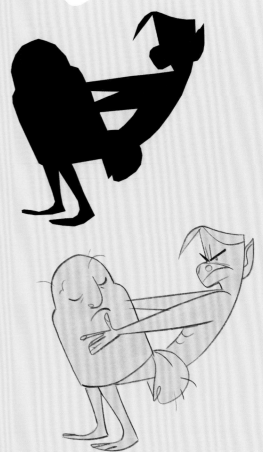

SIMPLE VS. COMPLEX

Creating balance between simple and complex shapes in your designs is an easy way to make your characters readable and dynamic. When you draw your character, pay attention to their overall shape and make one side more complex than the other. On the simple side, I like to include smooth curved lines, to contrast with the hard, straight lines on the complex side. This can be done when refining details such as arms, legs, and clothing, and will increase the interest of your design.

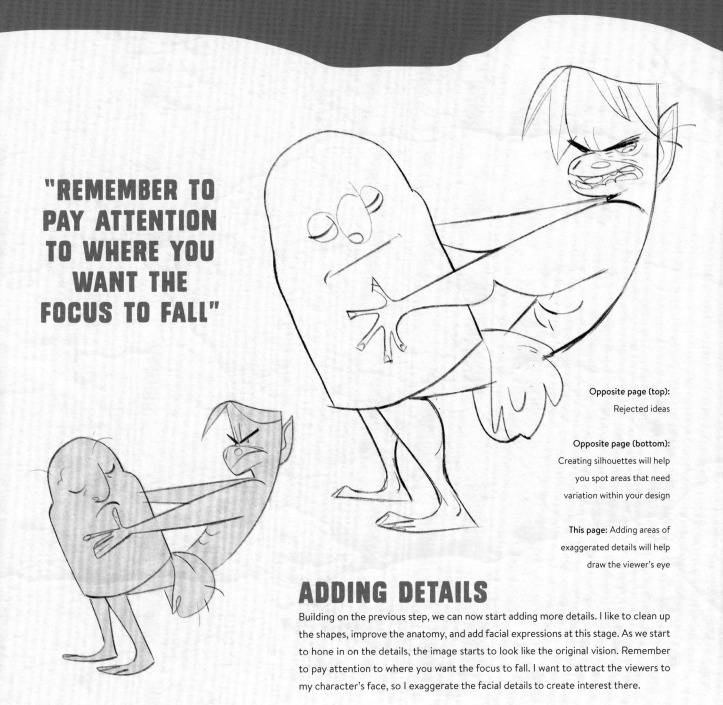

"REMEMBER TO PAY ATTENTION TO WHERE YOU WANT THE FOCUS TO FALL"

Opposite page (top):
Rejected ideas

Opposite page (bottom):
Creating silhouettes will help you spot areas that need variation within your design

This page: Adding areas of exaggerated details will help draw the viewer's eye

ADDING DETAILS

Building on the previous step, we can now start adding more details. I like to clean up the shapes, improve the anatomy, and add facial expressions at this stage. As we start to hone in on the details, the image starts to look like the original vision. Remember to pay attention to where you want the focus to fall. I want to attract the viewers to my character's face, so I exaggerate the facial details to create interest there.

CREATING PROPS

In the back-story I created, I established that this character destroys the human statues he discovers, so I want to include a statue in the image. To do this, I carry out some research into Japanese praying statues, then take these references and start to figure out how they can work within the image. I select the middle statue design as it has a strong, simple structure that I like. I will make the statue larger, so our creature will look under strain as he moves and destroys them.

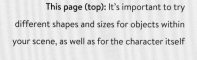

This page (top): It's important to try different shapes and sizes for objects within your scene, as well as for the character itself

This page (bottom): Neaten up the line art and add some extra details

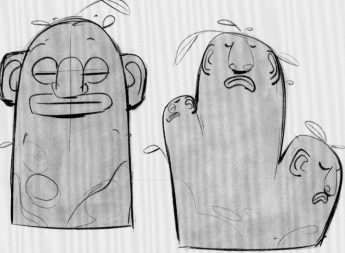

LINE WORK

Now the main form of the character and background details are planned out, we can move on to the line work. How you refine the line work is up to you – some artists prefer a cleaner line, whereas others prefer a sketchy look. I like to make my lines as clean as possible, but to make my character appear aged I draw them with a textured brush. One way to achieve clean lines is to draw them quickly, with one stroke. This can take a lot of practice, but you'll become more confident the more you use this technique. One of the benefits of working digitally is that if you're not happy with the line, you can use the undo button to go back and create the clean, broad stroke you're after.

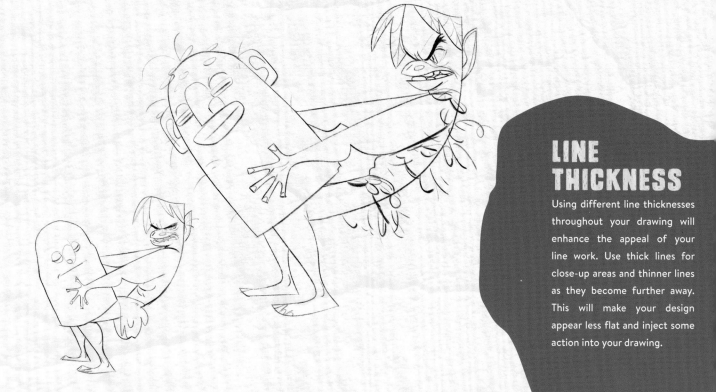

LINE THICKNESS

Using different line thicknesses throughout your drawing will enhance the appeal of your line work. Use thick lines for close-up areas and thinner lines as they become further away. This will make your design appear less flat and inject some action into your drawing.

STRUCTURE

Having a clear understanding of the underlying structure is important when posing and painting a character. When you understand the shapes in three dimensions, it becomes easier to draw a character in different poses and have them interact with objects in the scene. This knowledge is also useful when it comes to painting, as it enables you to figure out how light will hit the character, and how the character will create shadow. This all makes it easier to create effective depth of field, to select colors, and to make your character look realistic.

This page (top): Understanding the form of your character will make your designs more believable

This page (bottom): It's important to try out a few color options before making a decision

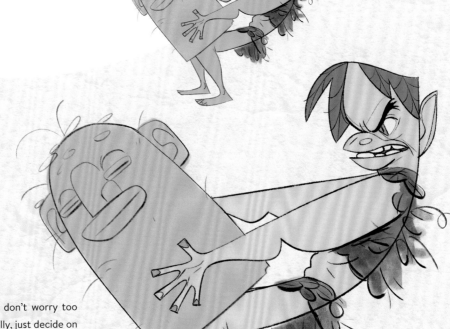

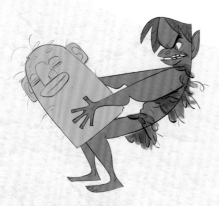

SELECTING COLOR PALETTES

When selecting a color palette for a character, don't worry too much about selecting the "perfect" colors – initially, just decide on a dominant color for the image. You can then develop other colors in the later steps. I generate four different color versions of my illustration to see which I prefer. In the end, I select the yellow as I like the contrast it creates, and the colors feel warm and vivid.

HIGHLIGHTS AND TEXTURES

Now we have established a base color, we can help make our character pop by adding highlights and texture. I want the creature to feel natural, as though he has come from the earth, so I make his skin appear wet by adding little highlights to make it look shiny. I construct his hair from leaves to give him an "overgrown" look, adding highlights on these leaves, too, as I would on real hair. For the statue, I add texture and shadows, then add a rock texture on top and set it to Overlay so the layers merge together nicely.

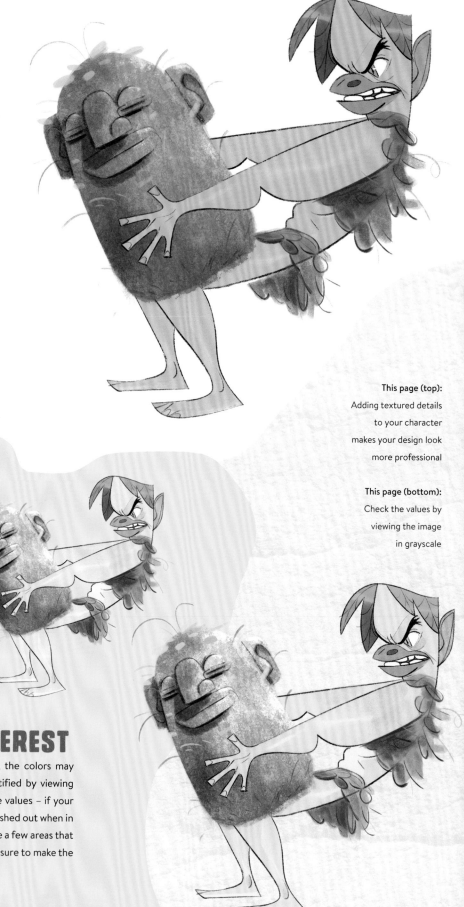

This page (top):
Adding textured details to your character makes your design look more professional

This page (bottom):
Check the values by viewing the image in grayscale

MAINTAINING INTEREST

Sometimes, after adding these smaller details, the colors may look a little off or pale. This can be easily rectified by viewing the image in grayscale, as this will bring out the values – if your image is lacking in contrast then it will appear washed out when in color. Viewing my character in grayscale, I notice a few areas that need some work, so I increase the light and exposure to make the design sharper and clearer.

LITTLE ADJUSTMENTS

As we approach the finish, I feel that the design still needs a few adjustments. One aspect that needs attention is the pose – I want it to be more obvious that the statue he is carrying is heavy and weighing him down. To create this effect I select his upper body using the Liquefy tool and move it slightly to the left, which makes his body appear under strain from the weight of the rock. I also increase the curve of his eyebrows to make him appear more aggressive, reinforcing the back-story we have created for the character. I also add some vines draping across the statue he's carrying, to further tell the story and make the creature appear ancient and overgrown.

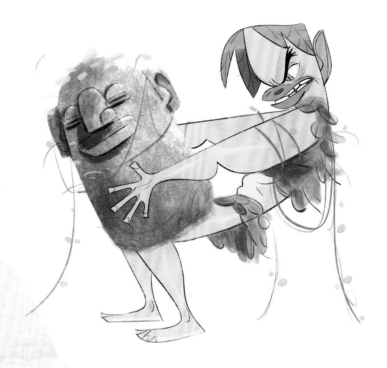

FINISHING TOUCHES

Now for the final touches to our illustration. My favorite thing to add at the end of the process is "Color Lookup." With this filter, you can make the character colors work better together and even change the atmosphere to nighttime or sunset – or even make it look like an old, ancient picture. I use it to make my character colors look a little old and warm. You can find this filter in the Adjustment menu, and once you've added the filter you need to change the layer mode to Color – this way, the filter will only fix the colors of the character.

This page (top): Pulling together the last details to sell the back-story for this character

This page (bottom): Simple adjustments can really sell your final design and make it look professional. Final image © Rudy Hill

THE GALLERY

In every issue we bring you exciting and inspiring designs to help spark your own character ideas. In this issue, we are showcasing fantastic work from Phillip Light, Abdullah Moatasem, and Alexis Austin. Each artist's exciting work embodies the storytelling and magical elements that make character design so captivating.

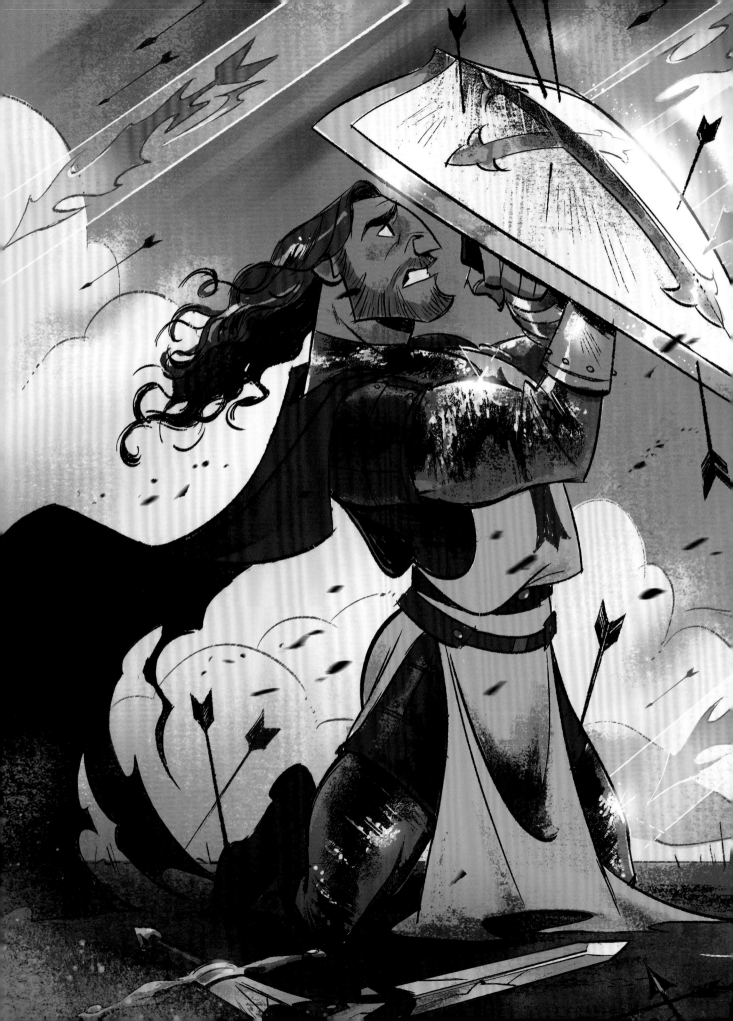

PHILLIP LIGHT CURRENTLY WORKS AS A CHARACTER DESIGNER AT DISNEY TELEVISION ANIMATION. HIS PAST CREDITS INCLUDE *BIG HERO 6: THE SERIES* AND *RAPUNZEL'S TANGLED ADVENTURE*, AND HE IS CURRENTLY WORKING ON *THE PROUD FAMILY: LOUDER AND PROUDER*. HE PREVIOUSLY WORKED AT DREAMWORKS TV AS A COLOR STYLIST ON *THE MR PEABODY & SHERMAN SHOW*.

ABDULLAH IS AN EGYPT-BASED, SELF-TAUGHT CHARACTER DESIGNER WORKING IN ANIMATION.
HE STARTED HIS CAREER AT THE AGE OF 16 AND HAS SINCE WORKED FOR MANY EGYPTIAN AND REGIONAL ANIMATION STUDIOS, AS WELL AS A FEW INTERNATIONAL ONES - MOST RECENTLY NETFLIX ANIMATION.

Abdullah Moatasem | abdullahmo.carbonmade.com | Images © Abdullah Moatasem

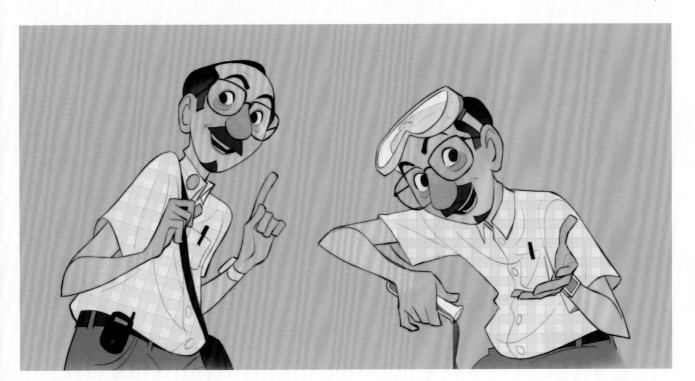

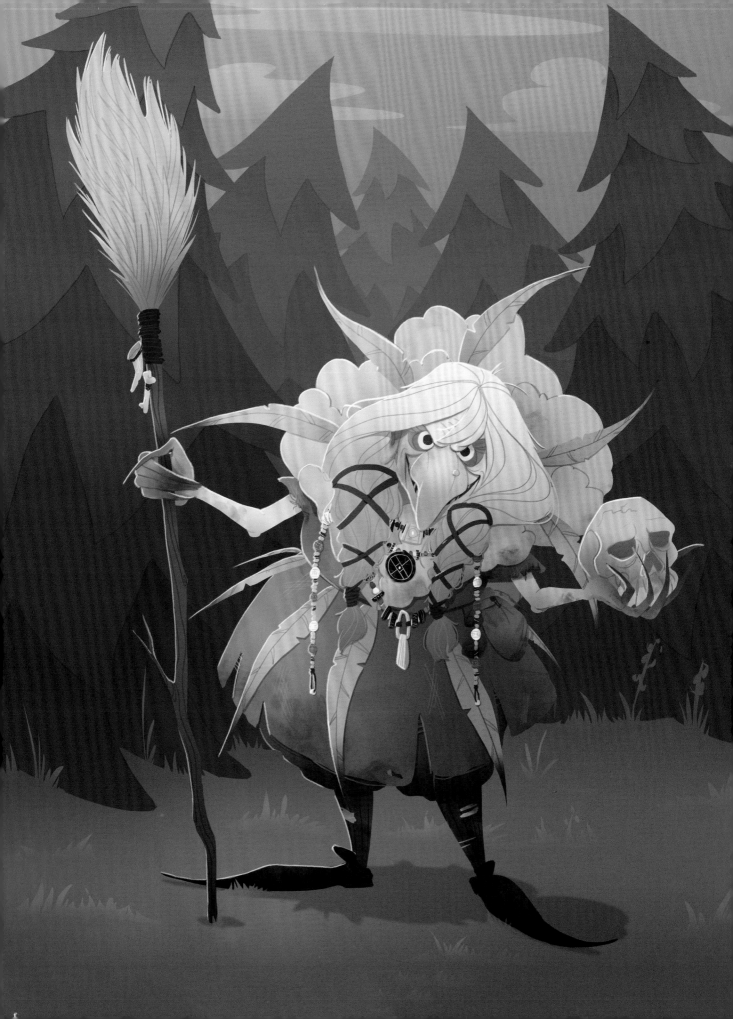

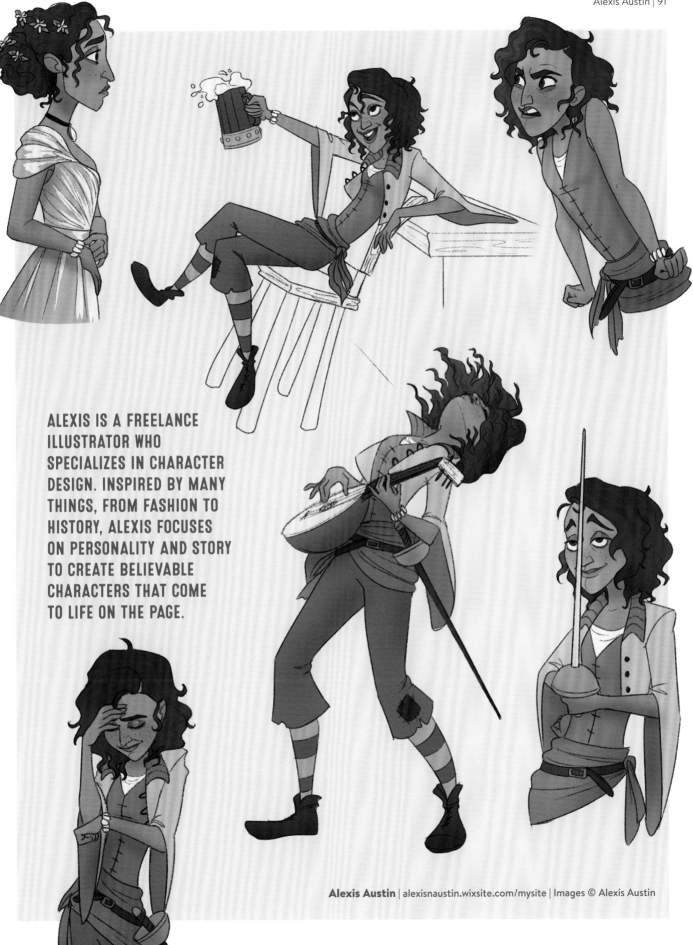

ALEXIS IS A FREELANCE
ILLUSTRATOR WHO
SPECIALIZES IN CHARACTER
DESIGN. INSPIRED BY MANY
THINGS, FROM FASHION TO
HISTORY, ALEXIS FOCUSES
ON PERSONALITY AND STORY
TO CREATE BELIEVABLE
CHARACTERS THAT COME
TO LIFE ON THE PAGE.

Alexis Austin | alexisnaustin.wixsite.com/mysite | Images © Alexis Austin

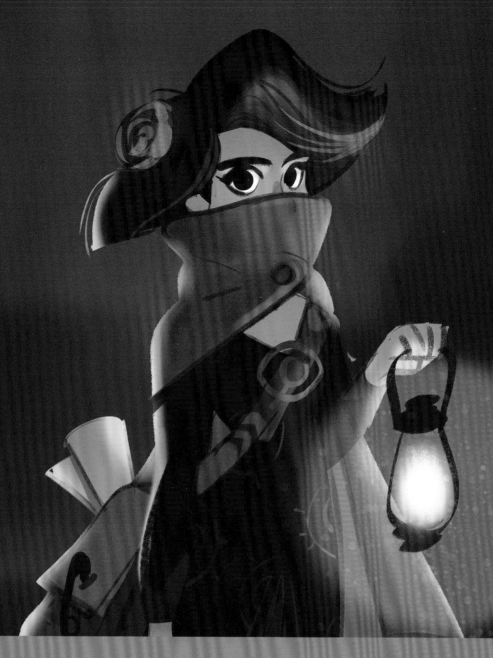

GIRL, SECRET, INTRIGUE, RED
TARANEH KARIMI

In this tutorial I will show you how a few short words can inspire and inform a character design. For this particular piece, I am using the words: Girl, Secret, Intrigue, Red. You can begin with any medium, whether it's pencil and paper or digital tools. I'm going to be using Adobe Photoshop with a Wacom Cintiq 24. I will also use Procreate to produce some of the sketches. Let's begin!

Final image © Taraneh Karimi

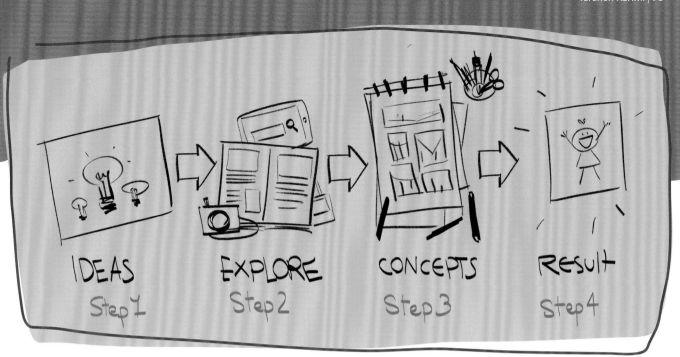

IDEAS
Step 1

EXPLORE
Step 2

CONCEPTS
Step 3

RESULT
Step 4

THE JOURNEY BEGINS

A journey of a thousand miles begins with a single step. It is always exciting to begin a character design for a personal project or a client, and you may want to jump straight in, but it's important to remember that it's all about the process. There is no shortcut or rush to the finish line in any design process.

WRITE THE WORDS

First, close your eyes and allow yourself to imagine all the things that your brief conjures up. It could be a character in a show, a comic you've read, a person you know, an object, a story, or maybe even a joke. Write all of this down on paper, without thinking too much or looking at what you've written.

This page (above):
It's always better to plan, be prepared, and move forward step-by-step

This page (below):
Once you've written down all your ideas, take a look and pick out some interesting results

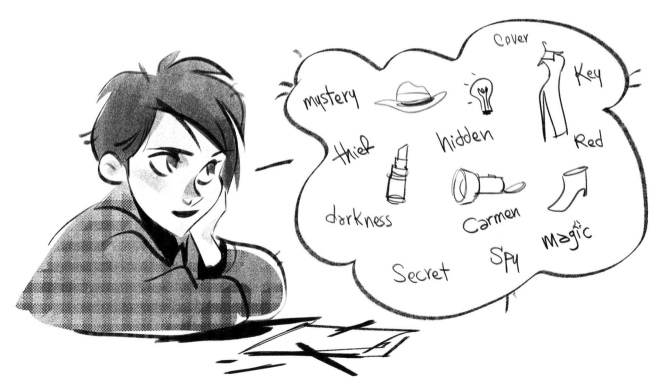

SPARK OF AN IDEA

Now that we have an abstract idea of the story and theme behind the illustration, let's go deeper and become more specific with our ideas. Take the words you have selected and repeat the exercise. Limiting your options and narrowing in on an idea will help your illustration feel focused.

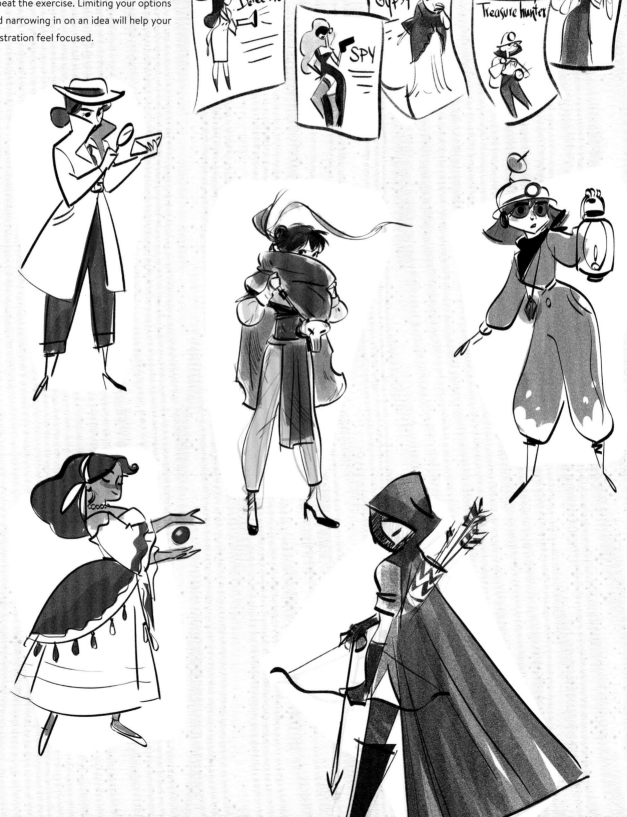

STORYLINE AND SILHOUETTES

Now it's time to start sketching. Using the concepts developed through the explorations, you can build a back-story for your character that can be shown through the design. We know our character needs to be intriguing and have a secret – start to think about how to combine these characteristics and how to communicate them through things like proportion and size.

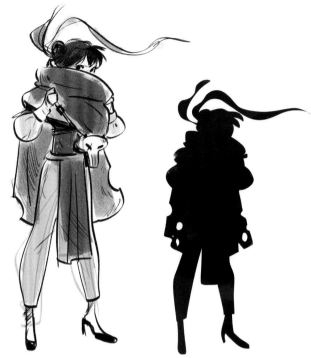

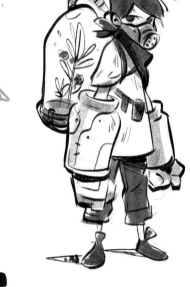

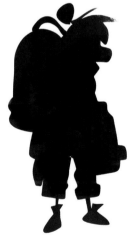

> "USING THE CONCEPTS DEVELOPED THROUGH THE EXPLORATIONS, YOU CAN BUILD A BACK-STORY FOR YOUR CHARACTER THAT CAN BE SHOWN THROUGH THE DESIGN"

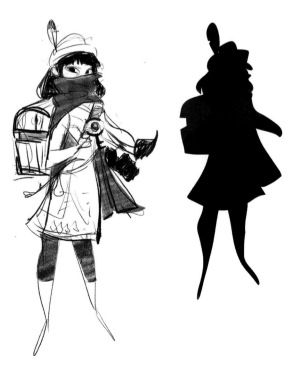

Opposite page: You will often find a gem when digging deeper into the initial concepts

This page: In your sketches, try to explore different proportions and silhouettes for your character

EXPLORING YOUR CHARACTER

The essence of your character is there, so now it's time to pick one of the designs and try a variety of ideas in a similar direction. It's important not to "fall in love" with any of your initial designs. Instead, keep them in your ideas box and seek new and different possibilities. Sometimes there is a lot of back and forth in this step, but your character will slowly show up, little by little, on the page. Remember, it's always a process.

"IT'S IMPORTANT NOT TO "FALL IN LOVE" WITH ANY OF YOUR INITIAL DESIGNS"

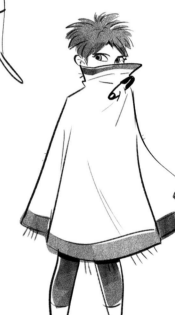

This page: At this point, you can start to see if the elements work together

Opposite page (top): Comparisons of good and bad value and contrast

Opposite page (bottom): Certain design choices can help direct the eyes throughout your illustration and communicate the story efficiently

USE REFERENCE

Reference helps make your character more believable. A character that is familiar to your audience, rather than completely made up in your mind, will be easier to sell. Studying real-life elements and characters will give you more possibilities to bring into your designs.

VALUE AND CONTRAST

Keeping track of the contrast throughout the design process will help your work appear consistently interesting. Try to make sure there is a variance in the size and proportions of shapes, and that there is a good balance between repetitive forms and ratios. You can use values within your design to create a focal point, leading the viewer's eyes to the main focus of your image.

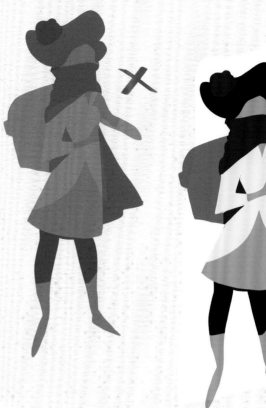

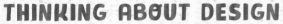

THINKING ABOUT DESIGN

What is design? When you break it down, design is what makes your character memorable and interesting. Every aspect of your character can help build a strong story and personality through silhouette, inner shapes, and lines. Even when you think you are done, think about how to make it more visually cohesive, rhythmic, and balanced. Being conscious about these elements will also help simplify the design without losing the story. The easier it is to read at first glance, the more your audience will connect with the character.

ASK FOR FEEDBACK

It's always a good idea to ask for feedback on your designs. Approach your family and friends – they likely don't know the brief you're working on, so it's a good test to see if your designs are readable. It can be insightful to ask someone with no professional drawing skills for their opinion, and they can be incredibly helpful. It's good practice, particularly when you are not working in a professional environment where you can bounce ideas off your peers.

FINAL DECISIONS

At this point you need to be thinking about the final design and how to make it a reality. Pick the elements you like the most and iterate your character concept. In production you will often find that character design leads might draw upon your design to make it more cohesive and balanced. Getting it to this point beforehand will help improve your skill and eventually you will take fewer steps to get to the final design.

This page: Finalize your sketches using the elements that best represent your concept

Opposite page (top): Keep in mind how the contrast and values you developed work with the color palette you select

Opposite page (bottom): Try out different expressions now that you know the basics of your character design

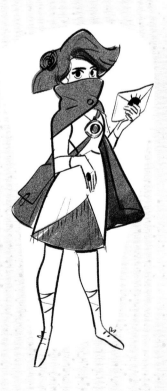
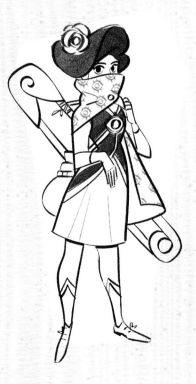
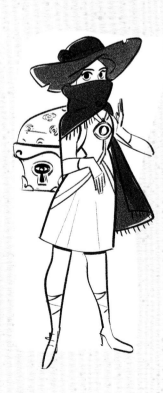

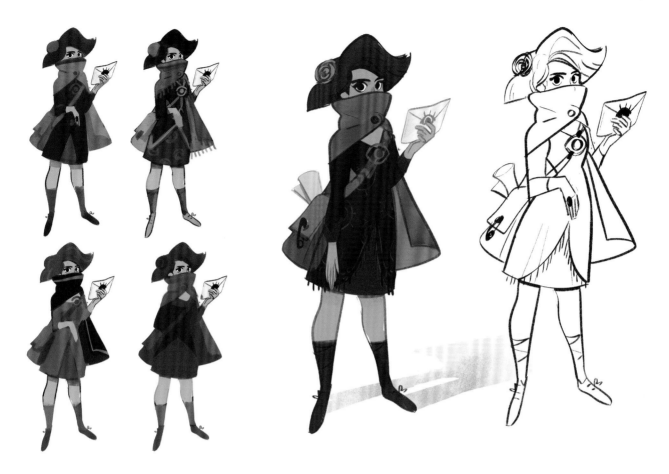

LADY IN RED

Colors and their combinations are just as important as shapes, as they can communicate emotions and characteristics that give us information about the character's personality. Having a unique and distinguishable palette will help tell your character's story. You can explore different color combinations with thumbnails – their smaller size helps to show how the colors complement each other in the whole piece.

EXPRESSIONS

Exploring your character through different emotions or actions will help add elements to your design that give more insight into your character. At this point, you have all the building blocks you need, so you can work on little changes to finalize the design. By focusing on the balance, rhythm, and aesthetics of the design, you can develop the shapes, lines, and details such as the facial expressions.

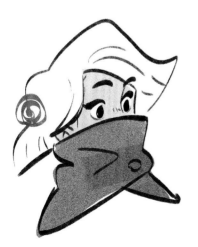

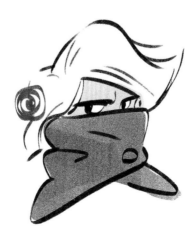

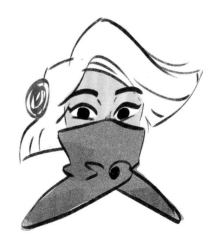

POSING

Through different poses, you can show the character's body language and what they are capable of doing. Going back to our brief, we want our character to evoke the words "intrigue" and "secret." How we pose our character in the final design, or for any character sheets, need to help sell this mood. Think about the choices you can make with the body to showcase these feelings, and combine these with the expressions and color palette for a balanced design.

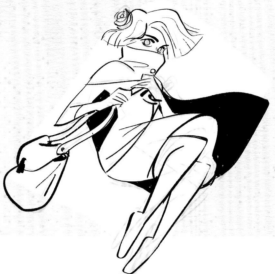

MODEL SHEETS

For many areas of the industry, it's essential to provide character model sheets once a design is complete. You need to be able to communicate the character quickly and efficiently through these sheets, so select the poses and expressions very carefully. These are taken by the 3D artists who are able to bring them to life through animation. Any props or gadgets you can give them will help to sell the character even more.

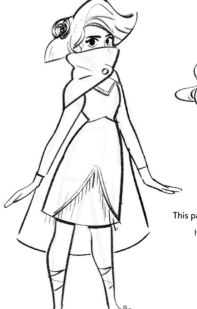

This page (top): Create various poses to show the story of your character

This page (bottom): Character model sheets help other artists interpret your design

Opposite page: For the final image, show your character in a suitable setting to tell their story

STAGING

Good job, you've made it! I like to "stage" my final design of a character, imagining I've set up a camera and set the scene. Use this opportunity to show your audience who your character is, presenting them in the best way possible.

CONTRIBUTORS

LYNN CHEN
Visual development artist
artstation.com/lynnchen

Lynn works at Warner Bros Animation and lives in Los Angeles with her family and the studio assistant – Mochi the Corgi.

DANI DIEZ
Freelance artist & art director
danidiez.com

Based in Madrid, Spain, Dani loves videogames and animation. He has worked for big clients but always makes room for personal projects.

SHANNON HALLSTEIN
Visual development artist
shannonhallstein.com

Shannon became a trainee at DreamWorks TV Animation when she graduated in 2019, and is now working there full-time.

RUDY HILL
Character designer
artstation.com/rudyhill

Rudy is a 24-year-old self-taught artist based in Libya. He is a co-founder and character designer at Desert Monkeys studio.

AMANDA JOLLY
Character designer
amandajollylines.com

A character designer in TV and feature animation, Amanda loves bringing characters to life while the TV is on in the background.

TARANEH KARIMI
Principal artist & art director
taraneh.me

Taraneh is a Persian artist based in the Netherlands. She has worked in motion graphics, games, and animation for almost a decade.

MITCH LEEUWE
Freelance artist
mitchleeuwe.nl

Mitch focuses on creating character and environment designs. He also teaches online and offers tutorial eBooks and videos.

VERONICA MATEI
Game artist
instagram.com/ver_matei

Based in Berlin working at King, Veronica started out drawing Hanna-Barbera characters and puts her passion into creating characters.

STUDIO MUTI
Creative studio
studiomuti.co.za

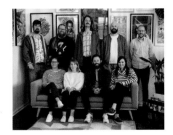

Based in Cape Town, South Africa, Studio Muti is a team of artists who are passionate about producing original and inspiring artwork.

RAQUEL OCHOA
Freelance illustrator
instagram.com/rachel_winkle

Raquel is an illustrator and digital artist from Spain who enjoys creating magical illustrations and characters in harmony with nature.

BEARDS
BY LORENZO ETHERINGTON

REMEMBER THAT BEARDS ARE **THREE-DIMENSIONAL OBJECTS** WHICH GROW **AROUND** THE FACE, **NOT** FLAT **ON** THE FACE.

FOR PRACTISE: EXPERIMENT WITH DRAWING **SIMPLE RANDOM 3D SHAPES** ONTO A CHARACTER'S **CHIN AND JAW**, THINKING OF HOW THEY **FIT AROUND** THE FORM.

GO CRAZY!

YOU CAN GIVE YOUR CHARACTER A **DISTINCTIVE BEARD** USING **SECTIONING.**

CREATE SEPARATE, DISTINCT SHAPES

CAN EVEN BE DONE WITH SINGLE SECTIONS

THERE ARE **MANY DIFFERENT WAYS** WE CAN SHOW A **CURL OR WAVE...**

TIGHT ROWS OF OPPOSITE WAVES

LOOSER, LINES CROSS OVER AND TANGLE

"WATERFALL" LONGER, FINER LINES